# PADDINGTON STATION

## THROUGH TIME

John Christopher

AMBERLEY PUBLISHING

The illustrations in this book enable the reader to explore many aspects of Paddington Station. They seek to document not only its history, its architecture and the changes that have occurred over the years, but also record the day-to-day life of this magnificent railway station. Remarkably, while some parts of Brunel's Paddington have been lost, remodelled, or superseded by later structures, as is to be expected with a working railway station on this scale, the essence of his Victorian masterpiece has survived miraculously intact. Indeed, it is probably in better shape than for some time and, consequently, there is much to be seen and appreciated to this day. Hopefully this book will encourage you to delve a little deeper when exploring Paddington Station and its environs, but please note that public access is sometimes restricted for reasons of safety.

First published 2010

Amberley Publishing Plc
Cirencester Road, Chalford,
Stroud, Gloucestershire, GL6 8PE

www.amberley-books.com

Copyright © John Christopher, 2010

The right of John Christopher to be identified as the Author of this work has been asserted in accordance with the Copyrights, Designs and Patents Act 1988.

ISBN 978 1 84868 962 6

British Library Cataloguing in Publication Data.
A catalogue record for this book is available from the British Library.

Typeset in 9.5pt on 12pt Celeste.
Typesetting by Amberley Publishing.
Printed in the UK.

# Introduction

Every year, millions of tourists pour into London, devouring its countless museums and art galleries, its famous historic buildings and monuments like a modern plague of biblical proportion hell-bent on fulfilling their heritage quota before moving on to the next tick box in the guide books. But if only the hordes would pause for a moment to look beyond the obvious, they might discover something of the real London; a vibrant, working city steeped in layer upon layer of living history.

They would do well to start with the capital's historic railway stations, a collection of grand structures dating from an age when Britain's men of iron were inventing the railway and cutting their way through the landscape to shape our modern world. London was at the hub of this transport revolution, like a spider in a web made of independent railway lines which grew out towards the far-flung corners of the nation. As a consequence, the city is encircled by some of the finest and most varied railway architecture to be found anywhere in the world. Moving clockwise from the Thames in the west, there is Victoria Station, then Paddington, Marylebone, Baker Street, Euston, St Pancras, King's Cross, Broad Street, Liverpool Street, Fenchurch Street, London Bridge, Waterloo and, piercing deeper into the city's heart, we have Charing Cross, Blackfriars, Holborn Viaduct and Cannon Street. Each and every one has its own story written into its fabric, into its bricks, iron and glass.

For the competing Victorian railway companies, their London termini were intended as a statement, a symbol of their solidity and corporate greatness. As the late Sir John Betjeman, a Poet Laureate and a man who knew and loved railways, once famously stated, 'If the station houses are the equivalent of parish churches, then the termini are the cathedrals of the Railway Age. Most companies, even if their origins were in provincial towns, were determined to make

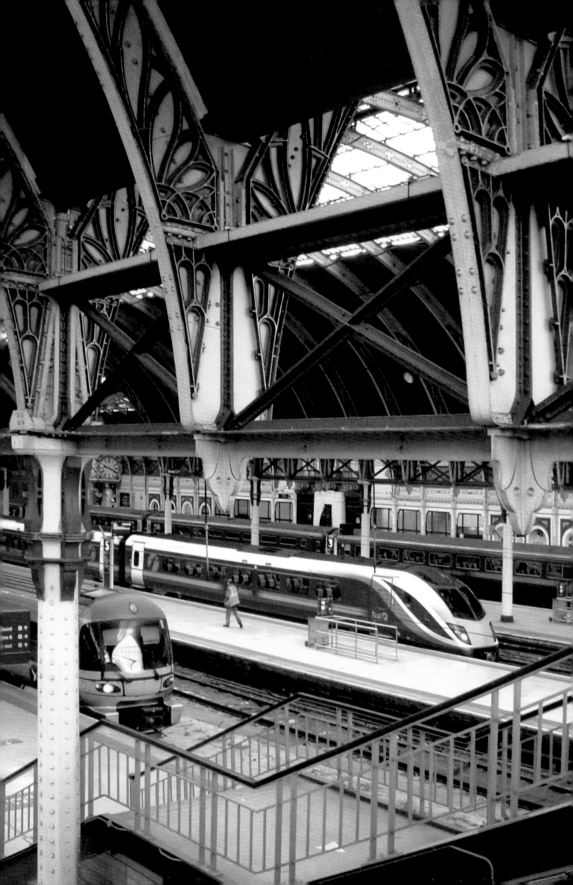

a big splash when they reached the capital.' None more so than the Great Western Railway, which had appointed the twenty-six-year-old Isambard Kingdom Brunel to build a railway connecting London and Bristol. Brunel was a talented and audacious engineer, a charismatic figure with the persuasive powers to carry the investors and company directors on his chosen path. From the outset, he was adamant that this was to be his finest work, a railway quite unlike any other.

'The route I will survey will not be the cheapest – but it will be the best,' he asserted. And he was right on both counts. To start with, he chose a route running along the Thames Valley, curving upwards to within ten miles of Oxford, and then on via Swindon to the north of the Wiltshire Downs and westwards to Bath and Bristol. A longer route than a straighter east-to-west line, but it was more level and offered greater opportunities for connections to other towns such as Oxford, Cirencester, Cheltenham and, via Gloucester, across to Wales. Arguably the most distinctive aspect of Brunel's railway was his choice of a wider gauge – the distance between the rails – which he believed was the key to a smoother ride. He rejected the 4-foot 8-inch gauge preferred by the Stephensons, chosen by them as it was already used by many northern collieries, and he went for a broad gauge of just over 7 feet.

Building work on the Great Western Railway, as it became known, commenced after the Act of Parliament received Royal Assent on 31 August 1835. Organisationally, the GWR was a railway in two parts, with one board of directors in Bristol and another one in London, and the plan was to construct the line from both ends. In practice, the Bristol end had to contend with the more difficult terrain, including the construction of the two-mile tunnel at Box, and as a result, the railway extended out from London much faster with each new station becoming the temporary western limit of the railway.

When it came to designing the many buildings for the railway, Brunel demonstrated a deft hand for architecture and a meticulous eye for detail. Perhaps the greatest example was his Bristol terminus at Temple Meads with its wide wooden roof and distinctive hammerhead beams – a purely decorative feature as it turns out. When it comes to architectural styling, Brunel's early work reflects the tastes and interests of his times, which, we should remember, were not only early Victorian but pre-Victorian. The station buildings were decidedly Italianate or Elizabethan Gothic in flavour, and Temple Meads is no exception with its front offices finished in high Elizabethan style. Further up the track, the exterior of Bath Station looks for all the world like an Elizabethan farmhouse which has been air-lifted into the middle of one of the most celebrated Georgian cities in the country.

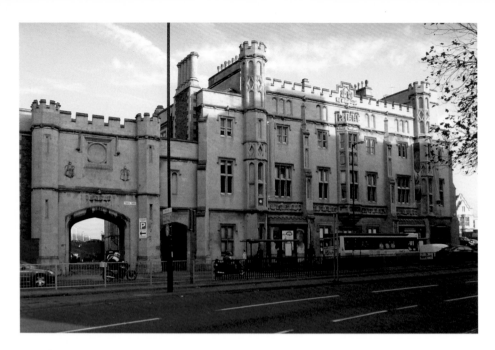

## Temple Meads Station, Bristol

Bristol's Temple Meads, at the western end of Brunel's GWR, was a far grander and more solid affair than the first Paddington. Fronting the terminus buildings are the directors' offices finished in an Elizabethan-Gothic style, flanked on either side by arches through which the horse-drawn carriages of the wealthy entered and left the station. Abutting this building is the Train Shed, a dead-end fitted with turntables to turn the locomotives around, and then came the Passenger Shed, depicted in J. C. Bourne's engraving below. Opened in 1840, its 74-foot-wide wooden roof, supported on decorative hammerhead beams, was celebrated as the widest in the world. The buildings are still standing, although the façade is minus the exit archway.

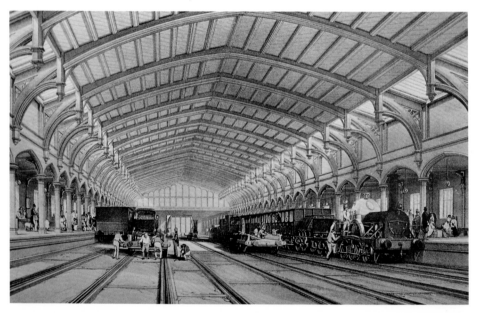

To the modern eye, this styling veers towards pastiche. But thankfully there is one glorious exception to be found at the other end of the Great Western Railway. The finest of all of London's great termini, Paddington is not only a superb building, it is also the great come-back station. It is not often that an engineer gets to revisit a project, a chance to try again, but that is exactly what happened here. The result is a rare example of Brunel's later work for the railways, one which also happens to be his finest. In place of pastiche we get the real thing, instead of brick and stone we have a glorious celebration of Victorian engineering in iron and glass at its finest.

So how did Paddington come to be so different to his other stations? The answer lies in its full name, Paddington 'New' Station. Initially Brunel had considered a number of locations for the GWR's London terminus, including the Paddington area, which was on the edge of the city's spreading built-up area. Because of difficulties in obtaining land to build the line into London, the company's directors decided to approach their rivals at the London & Birmingham Railway (L&BR) with a view to sharing facilities. This would have been achieved via a junction near Wormwood Scrubs and a joint line leading to the present Euston Station site. Accordingly, Brunel met with Robert Stephenson, engineer to the L&BR and a life-long friend, to discuss how the station could be split between the two companies and fronted with a public façade designed by a jointly appointed architect. In the end, the GWR's directors became concerned that the L&BR would have too much influence on their future operations and, together with the vexed question of the competing gauges, they decided to look again at an independent terminus at Paddington.

With typical gusto, Brunel drew up plans for a station with an imposing classical stonework façade featuring a central archway for carriages leading through to a roadway between the platforms. It seems quite likely that he still envisioned the wealthy passengers being transported in their own carriages carried on the railway wagons, as was the practice when the GWR opened. By the time the Act of Parliament permitting a terminus at Paddington had been passed, however, it was clear that the cost of constructing the GWR was already way over budget and its engineer had better make some cut-backs. Brunel's plans for a grand terminus were shelved and work began instead on a temporary station at the northern end of the Paddington site. A turn of events that would prove fortuitous in the long run, as it bought Brunel time to revisit his designs for a more grandiose station, while also allowing for some significant new building technologies to come to the fore.

# The First Paddington Station

Ever the pragmatist, and concious that it was only to be a makeshift arrangement until more land became available, Brunel wasted little time or resources on the original terminus at Paddington. The site, to the north-west of the present station, was located within a shallow bowl tucked beneath a spur of the Grand Junction Canal, known as the Paddington Basin, which had opened in 1801. Access to the canal would be useful, especially when it came to delivering building materials to the station site, and the lower ground level provided for a more gentle gradient for the railway line in and out of London. Most of the land belonged to the Bishop of London, hence the name for the Bishop's Road Bridge which the GWR was required to build across the site. An expensive exercise in itself, this brickwork bridge became the station's public façade. Nine arches housed the booking hall, waiting rooms, parcel office, cloakrooms and the entrance to the arrival platforms, as well as an entrance and exit for the carriages of the wealthier travellers.

The station itself was a collection of timber platforms protected from the elements by simple wooden roofs supported on slender iron columns. There were five lines of track with two platforms for departures separated by a roadway for carriages from the arrivals side platforms. At the end of the platforms was a series of wagon turntables and beyond these were the main carriage shed and an engine house. The latter was designed by the GWR's locomotive superintendent, Daniel Gooch, and featured an innovative polygonal 'roundhouse' layout with central turntable. If viewed from the end of the platforms of today's Paddington Station, the site of the original was situated beyond the Bishop's Road Bridge, having only a wooden goods shed located on the nearer side with rail access to it via arches on the left-hand side of the bridge.

This first station opened for business in June 1838 and initially the trains ran only as far as Taplow, near Maidenhead, until the workable line was completed in stages. Its cluster of wooden structures soon proved woefully inadequate however, and the company directors gave the go-ahead for the construction of a new terminus in late 1850.

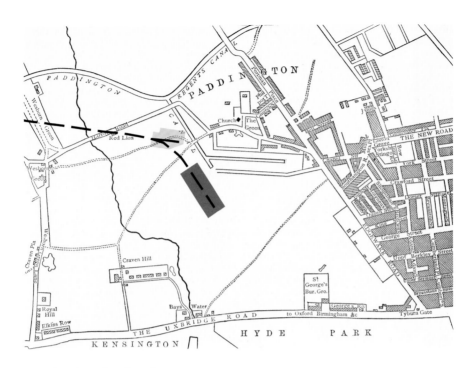

## Location, location, location

This 1815 map of the Paddington area, made before the building boom of the 1820s, shows the 1838 station added in orange and its 1853 replacement in red. The original station was very basic and consisted of wooden roofs supported by slender iron columns. The engraving of the covered roadway between the departures and arrivals platforms was published in *The Illustrated London News* in 1843.

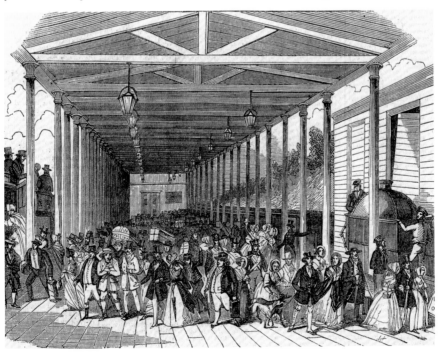

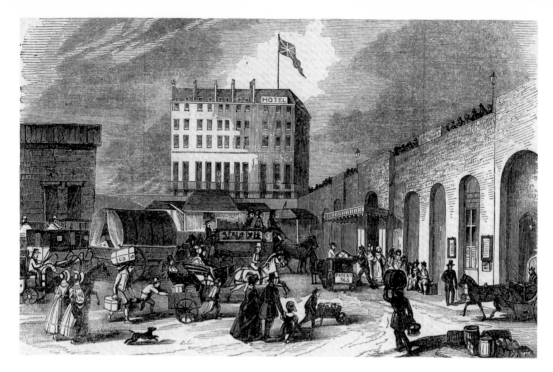

## Under the bridge

The GWR was required to build a bridge to carry Bishop's Road across the valley at Paddington as part of the agreement to use the land, and this became the public frontage to the original station. Travellers are seen arriving in this *c.* 1840 engraving, looking south towards the Prince of Wales Hotel and the cottage-like goods office. The modern view shows the most recent incarnation of the bridge.

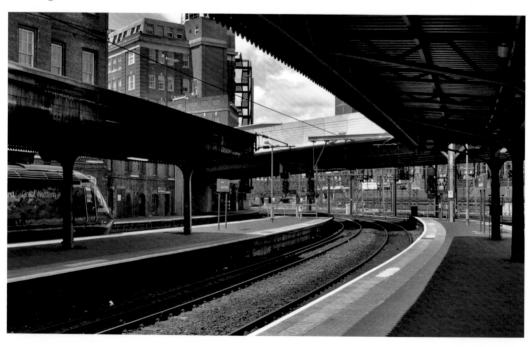

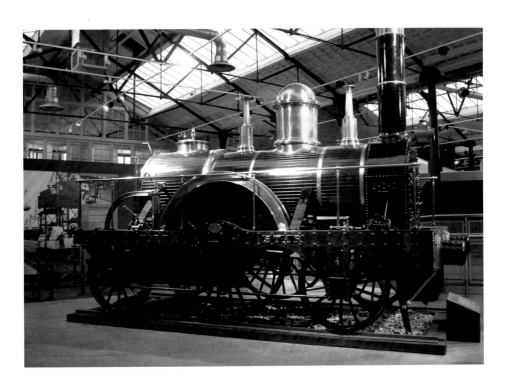

*North Star*

On 31 May 1838, the *North Star* hauled the first passenger service out of Paddington on the twenty-four-mile section of main line to Maidenhead. Built by Robert Stephenson's Newcastle company for an American customer, it was adapted to the broad gauge after Brunel's attempts to design locomotives proved unsatisfactory. This replica was created for the GWR's centenary celebrations and is now displayed at the STEAM Museum, Swindon.

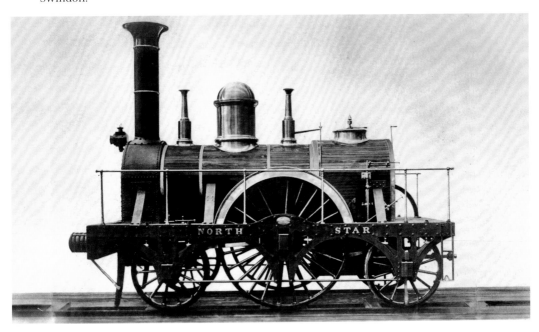

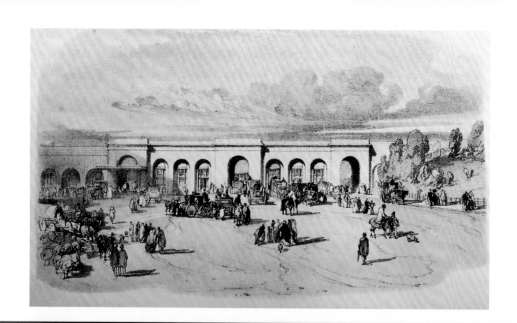

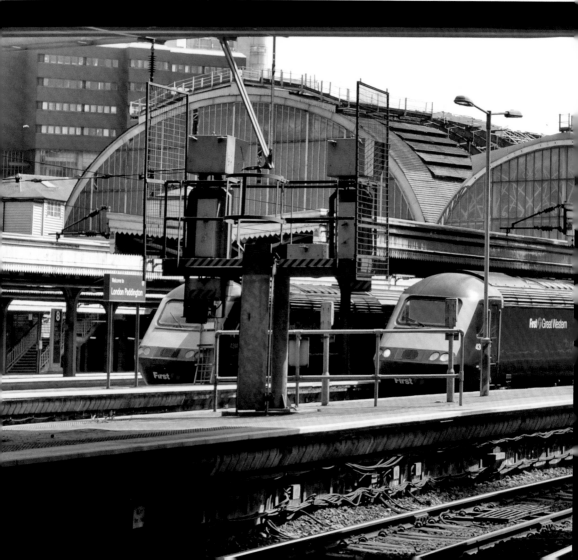

**From old to new**

J. C. Bourne's engraving from the 1840s depicts the wide Bishop's Road Bridge with nine of its arches housing the original Paddington Station's entrances, booking hall and other public rooms. This view is from the southern side of the bridge looking outwards from the site of the present station, and to the left are further arches for tracks leading to the goods offices and sheds. The modern view is from the end of Platform 1, looking backwards under the new bridge towards the new station; from the left is the fourth span, added in Edwardian times, then two of Brunel's three spans of iron and glass. A cluster of First Great Western trains sits on the track, which bends to the right as it enters the Paddington site.

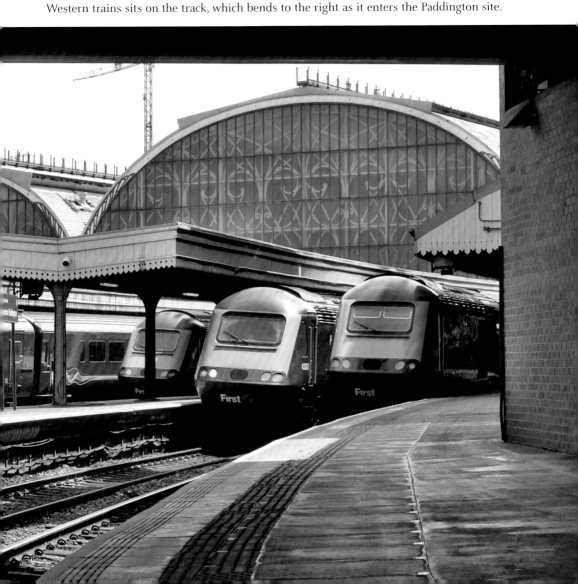

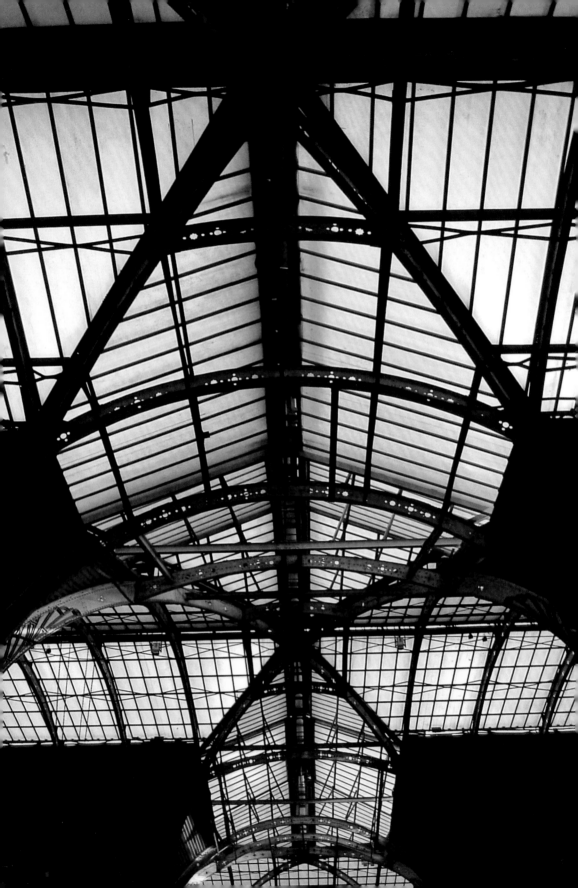

# Iron and Glass

'I am going to design, in a great hurry, and I believe to build, a station after my own fancy; that is, with engineering roofs, etc. etc. It is at Paddington, in a cutting, and admitting of no exterior, all interior and all roofed in.'

In these words written by Brunel in January 1851, his delight at the prospect of building a replacement and permanent station at Paddington is self-evident. The new station was to be built on the plot of land just south of the Bishop's Road Bridge, defined by Eastbourne Terrace and Praed Street on two sides, and by London Street and the canal on the north-east side. As this site did not line up with the existing main line, the tracks would take a fairly sharp turn to the right and had to pass through the arches of the bridge before entering the station. Because the new station would be located almost entirely within a cutting, there would be no grand exterior and instead Brunel would impress with his immense roof of iron and glass.

Brunel was always willing to draw inspiration from the work of his contemporaries, and it has often been suggested that his main source of influence for Paddington was Joseph Paxton's famous 'Crystal Palace' – a term coined by *Punch* – which was being built for the Great Exhibition of 1851. In truth, both structures were pre-dated by Paxton's seminal iron and glass conservatory built for the Duke of Devonshire at Chatsworth House, in Derbyshire, between 1837 and 1840. This Great Conservatory was 300 feet long and featured a 70-foot-wide central nave, making it the largest glass building in the world at the time. It cost the Duke over £30,000 to build, and because it leaked prodigious amounts of heat supplied by eight boilers, it became known as the 'Great Stove'. It was the building of this glasshouse that enabled Paxton to refine the techniques for constructing large prefabricated iron and glass structures.

Sandwiched between the Great Conservatory and the Great Exhibition were other significant buildings of iron and glass. The 363-foot-long Palm House at the Royal Botanical Gardens, Kew, built between 1844 and 1848, resulted from a collaboration between the

*Opposite page:*
**Brunel's greenhouse**
The morning light pours in to reveal an intricate tracery of girders where the main transepts are intersected by one of the two crossways transepts.

Irish iron founder Richard Turner and the architect Decimus Burton. It was the first building to use newly patented rolled wrought-iron I-beams, originally designed for shipbuilding. These ribs were rolled at Malins & Rawlinson's works at Millwall, then shipped to Turner's works in Dublin for joining and shaping into curves. Wrought-iron deck beams were also used to span the bases of the main transept, giving rise to the observation that it resembled an upturned ship. Indeed, a comparison of the Palm House, the Crystal Palace and Paddington reveals a similar cross-section with semicircles surmounted on vertical columns, and it is no surprise that Brunel's roof was also described as being boat-like. Mention must also be made of John Dobson's 1845 curved train shed at Newcastle, which had three arches each 60 feet wide.

Brunel was certainly aware of these other designs, and as a member of the Building Committee appointed to choose the design for the Great Exhibition building, he enjoyed a friendly working relationship with Paxton. To fabricate the roof at Paddington, Brunel brought in contractors Fox & Henderson, the company that had constructed the Crystal Palace, and together they worked in a close collaboration between engineer and builders.

The roof of Paddington's Train Shed, to give it its official name, consists of three parallel transepts, or spans, each 700 feet long. The central one is the biggest at 102 feet 6 inches wide, and it is flanked by two smaller ones approximately 70 feet wide, making it the largest train shed in existence at the time it was built. Each transept consists of curved wrought-iron girder arches, spaced 10 feet apart, which were originally supported by slender iron columns at 30-foot intervals, but these were later beefed up with steel replacements. The arches are perforated with a pattern referred to as 'stars and planets', and while these are decorative in their own right, their main function is probably to save weight. Between each column are two 'floating' arches, supported only by cross-braced girders running between the column heads.

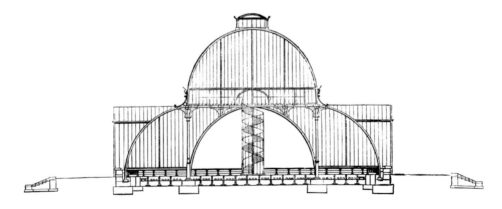

Cross section through the Palm House at the Royal Botanical Gardens, Kew. (King's College London)

16

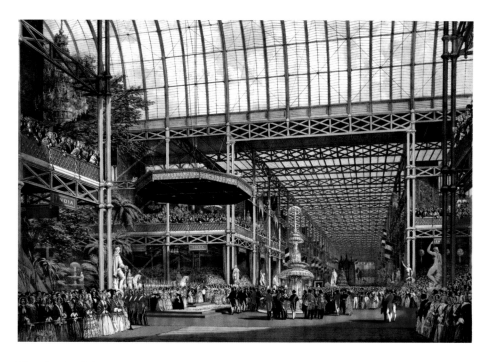

## The shock of the new

Joseph Paxton's winning design for the Great Exhibition at Hyde Park was a spectacular demonstration of what the latest materials and modular construction techniques could achieve. Christened as the 'Crystal Palace' by *Punch* magazine, and opened by Queen Victoria on 1 May 1851, it is actually pre-dated by the Palm House at the Royal Botanical Gardens at Kew, which was completed three years earlier in 1848. (RomanyWG)

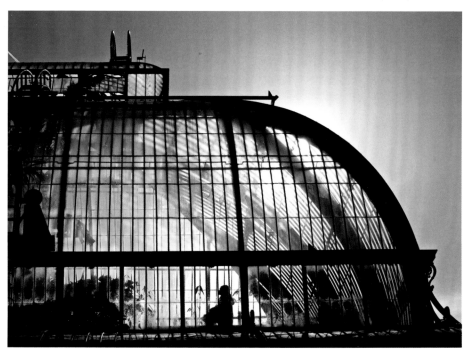

Adding to the church-like impression, the three spans are punctuated by crossways transepts, 50 feet wide, at one-third intervals lengthwise with one aligned with the Moorish windows of the Directors' Room overlooking the Departures Platform, or Platform 1. The junction between the crossing transepts creates a fascinating and complicated interchange of girders. Covering the roof is a system of ridge-and-farrow glazing known as Paxton roofing and originally designed by him for the first Chatsworth glasshouse.

To complete much of the decorative detailing at Paddington, Brunel recruited the architect Matthew Digby Wyatt, not because he was incapable of doing the work himself but because he was simply too busy with countless other projects at this point in his career. Wyatt provided the petal-like embellishment on the arches – a decorative and strengthening feature – and the almost Art Nouveau tracery at the gable end of the spans, which serves a dual purpose in providing extra rigidity to the roof while letting in light.

Instead of the grand frontage originally envisioned by Brunel for the Praed Street end of the station, the directors of the GWR decided to build a hotel. As a result, access to the station was created via a sunken roadway built alongside Eastbourne Terrace, or down the slope from Praed Street on the arrivals side. At ground level the internal layout of the station followed conventional lines with the 'Grand Departure' platform on the south side, and the arrivals platforms under the third span on the opposite side. Most of the central area was taken up with a trackbed leading to turntables, although this was later replaced by additional platforms.

Much of the recent restoration work at Paddington has stripped away the clutter which obstructed the view of the great space during much of the twentieth century. Today the modern traveller can enjoy an unimpeded view of the full length of the station, much as Brunel had intended, and when fingers of sunlight cut through the air, the magic still casts its spell.

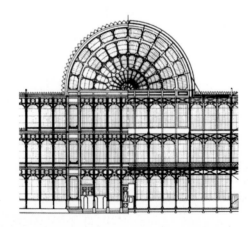

Cross-section of the central transept of Paxton's Crystal Palace. (Library of Congress)

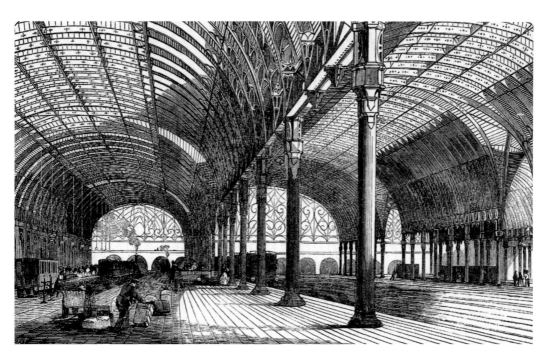

### Paddington 'New' Station

A contemporary engraving of the newly opened station looking towards the 'country' end with the arches of the Bishop's Road Bridge in the distance. Brunel's original slender iron columns are clearly visible and these were later replaced by beefier steel columns in a process completed in the 1920s. The intersection of the main transept and one of the two crossways transepts is shown below.

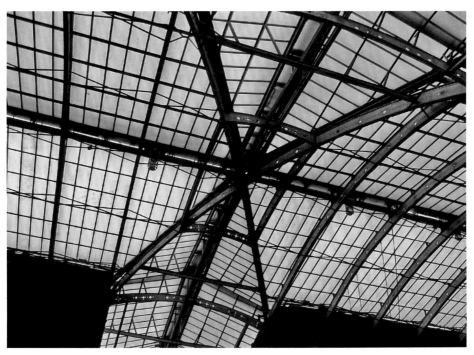

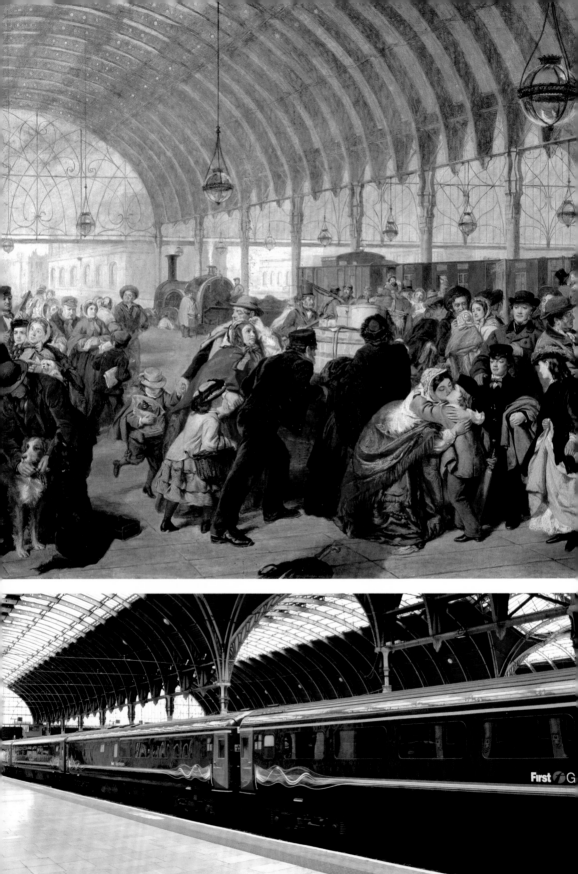

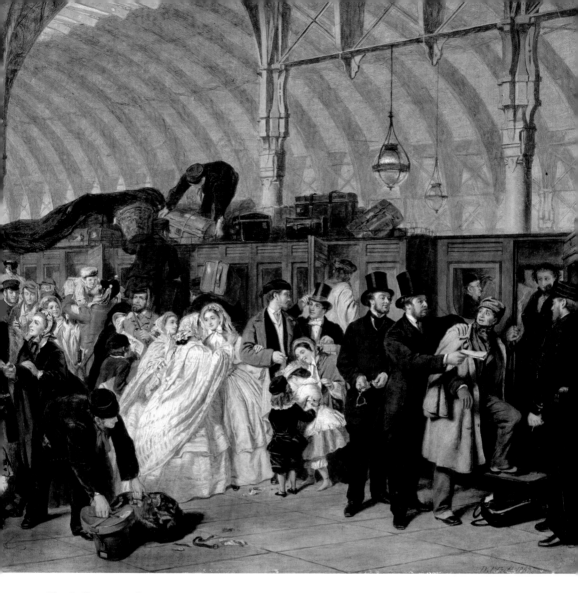

### The Railway Station

It is still possible to find the exact viewpoint on Platform 1 – just beyond the GWR Memorial – from which the Victorian artist William Powell Frith composed his celebrated painting of Paddington Station. This, and his other paintings, such as *Derby Day*, attracted great acclaim for their rich narrative content telling the stories of a wide cross-section of characters. The painting also appears to be an accurate record of the station at that time, showing a broad gauge locomotive as well as the roof detail, lighting and the decorative ironwork on the gable ends. Over 21,000 people paid to see it when first displayed at the Hayward Gallery in 1862, and countless more bought the mass-produced prints.

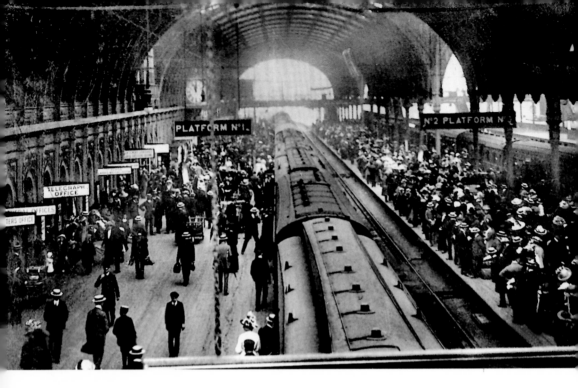

## Grand Departures Platform

Platform 1 was also known as the Grand Departures Platform thanks mainly to its Royal associations, as it served both Windsor and Eton School. The above postcard from *c.* 1910 shows the crowded station swarming with straw-hatted schoolboys, while the lower card, published by Tucks at around the same time, depicts the comings and goings on Platforms 5-7 beneath the central span. Note the 'toplight' carriages in both images.

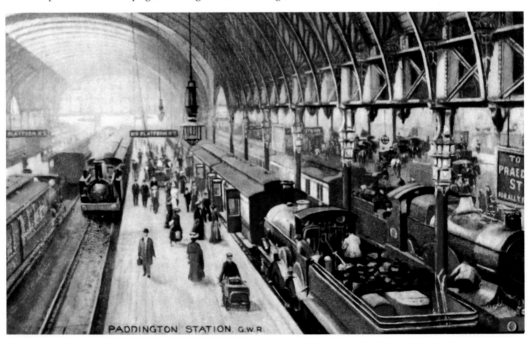

PADDINGTON STATION. G.W.R.

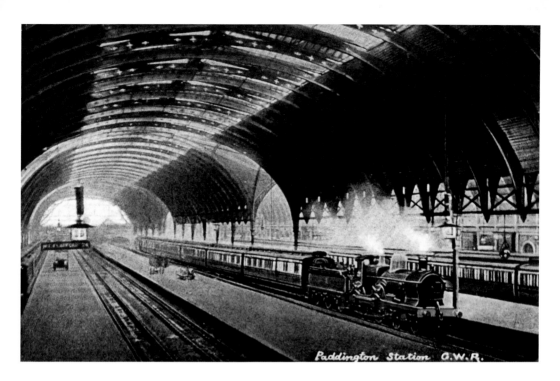

Paddington Station G.W.R.

### Pulling power, old and new

Two images of locomotives at Paddington. The top card, posted in 1904, shows a Barnum-class 4-4-0 locomotive in distinctive GWR green with carriages of brown and cream. During the age of steam, the station interior became decidedly grubby after years of exposure to the soot and dirt. In stark contrast, the yellow-and-blue-liveried 43025, an HST operated by First Great Western, pulls into today's Paddington.

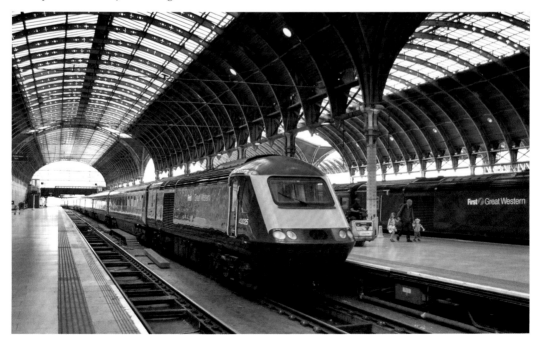

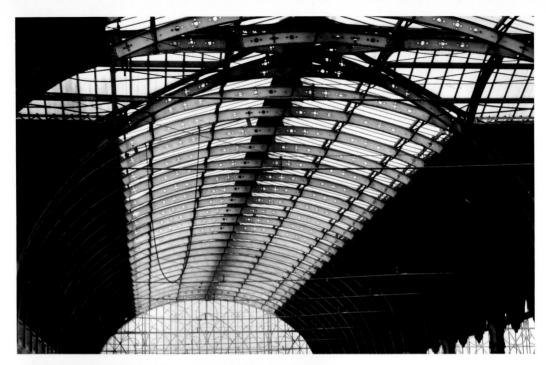

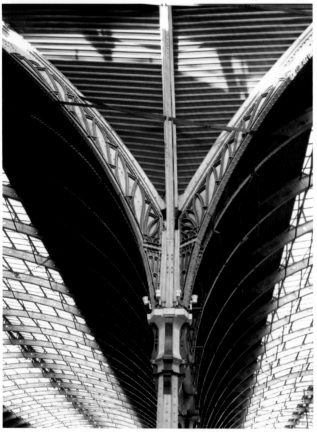

## Paddington's roof

To complete the finishing details at Paddington, Brunel called upon the architect Matthew Digby Wyatt. However, it is not clear if Brunel or Wyatt came up with the 'star and planets' motif that perforates the iron arches. Neither is it known if they are purely decorative or were intended to reduce weight, but either way, they do lighten the structure visually. Wyatt was responsible for the petal design, cast in iron and bolted on to the base of the arches to add strength. Great care was taken to restore the original colour scheme in the recent renovations.

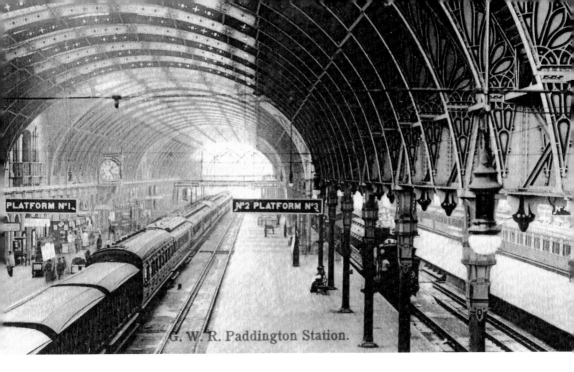

G. W. R. Paddington Station.

### Floating arches

The curved arches are spaced at 10-foot intervals and rest on iron columns 30 feet apart. This means that between each pair of columns there are two 'floating' arches supported by cross-braced girders between the column heads, keeping the interior very open but putting enormous stresses on the cross members. Curiously, the bosses beneath the ends of the floating arches are actually made of timber.

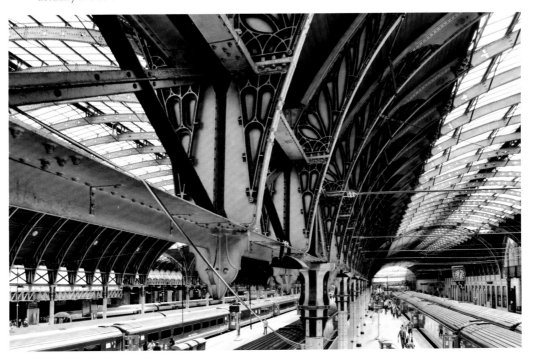

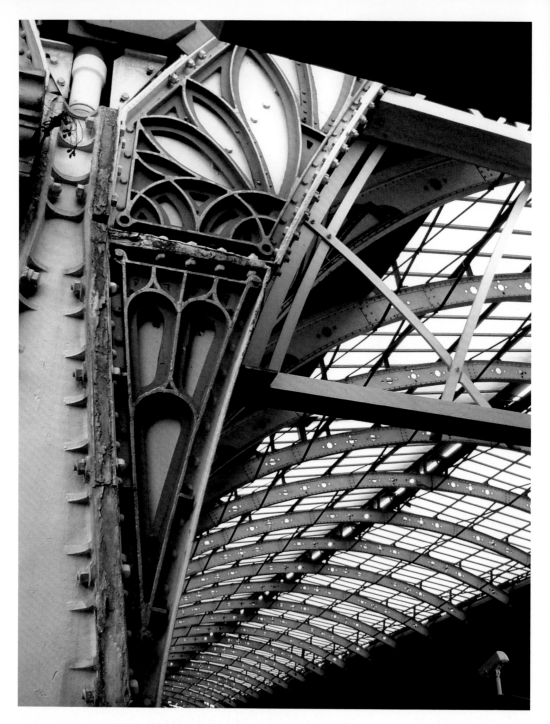

**Decorative detailing**
Close-up of the petals on the column heads and base of the roof arches, in this case the uncoloured arch at the 'country' end of the roof. On the left-hand side you can see the corner of Wyatt's decorative scrolling – which provides additional stiffening at the end of the main transepts – also shown on the opposite page.

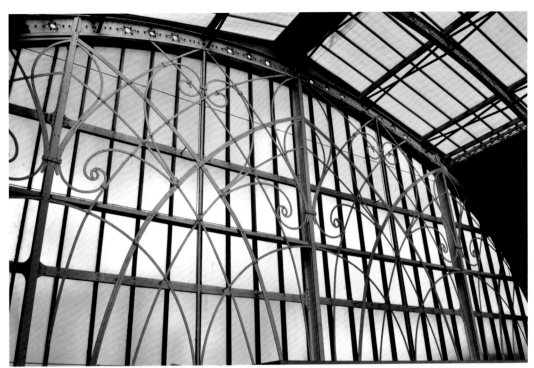

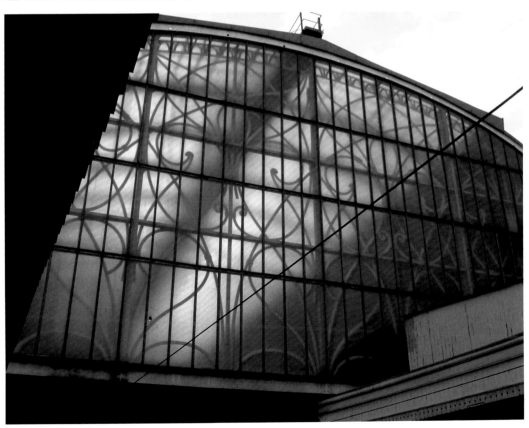

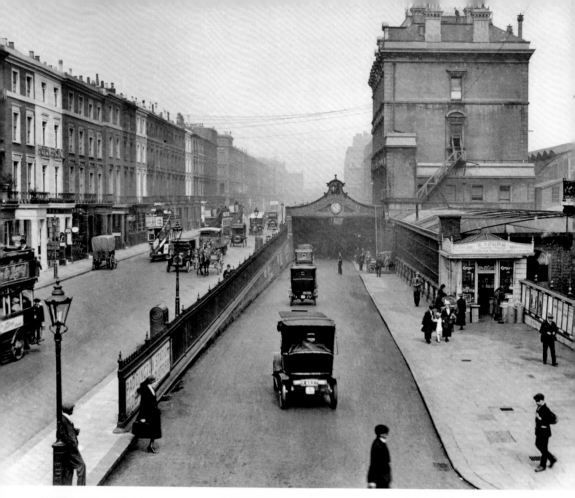

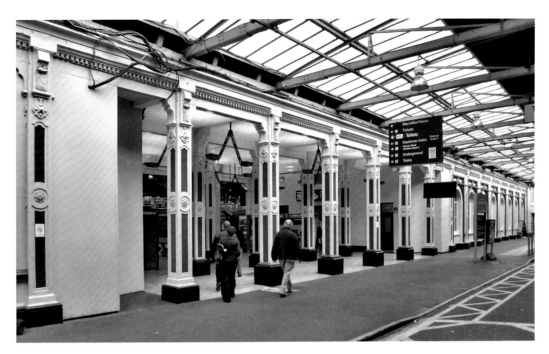

**Departures Road and entrance**
The main entrance for travellers
is via the Departures Road which
runs the length of the station
parallel to Eastbourne Terrace.
In the photograph from *c.* 1920 a
handful of taxis descend towards the
entrance canopy. (STEAM Museum
of the GWR) The company offices
rise above the entrance and the gap
in the buildings to the right has
since been filled in, and nowadays,
a continuous one-way flow of taxis
passes through from the Bishop's
Bridge end. New taxi facilities are
planned on the north side of the
station to make way for the Crossrail
station to be built under the road
itself.

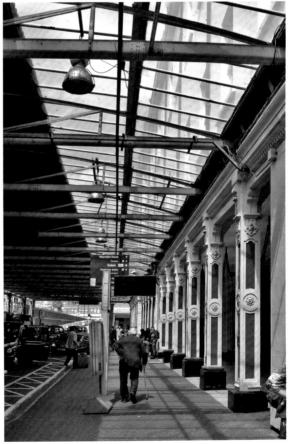

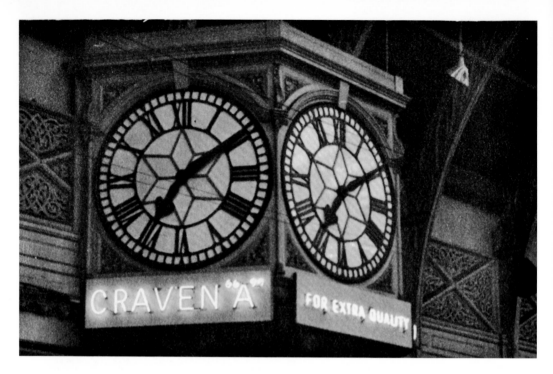

### The station clock

The clock arch, where the Departures entrance opens onto Platform 1, has long been a popular meeting point at Paddington. Made by Kays of Worcester, the clock's three 7ft 6in faces have been telling the time since 1903, and it is shown here in the 1950s with advertisements for Craven 'A' cigarettes.

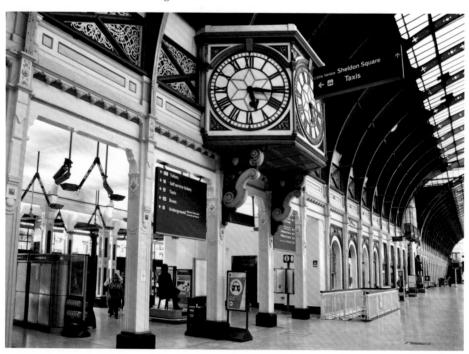

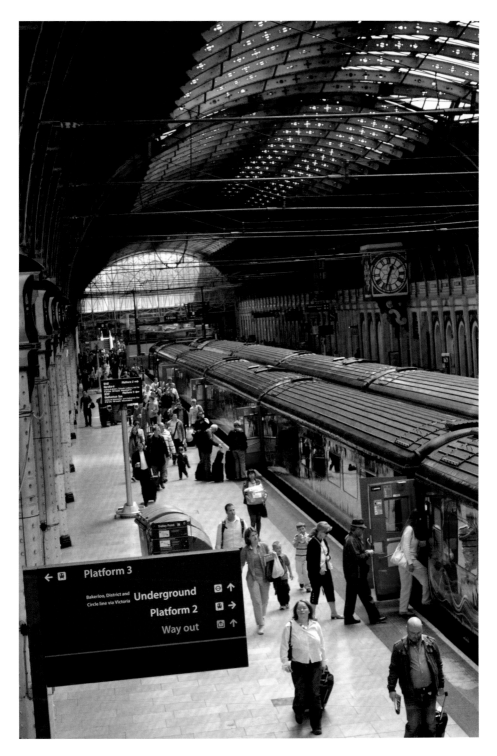

Looking from Platform 2 towards the Lawn and Platform 1, with the station clock seen beyond the trains. The clock was mechanically driven until 1929 when it was converted to electrical operation controlled from the Station Master's office.

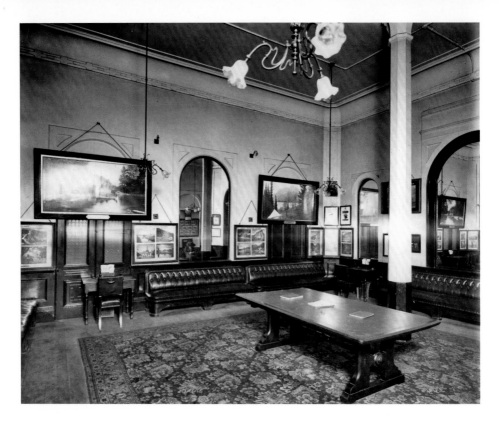

**Waiting rooms and GWR Memorial**
On either side of the GWR Memorial, designed by the sculptor Charles Sargeant Jagger and unveiled on Armistice Day, 1922, are the entrances to the former First Class and Royal Waiting Rooms as indicated by the royal and the GWR coats of arms above the doorways. First Class passengers could await their trains in comfort as shown in this 1912 photograph. (STEAM Museum of the GWR)

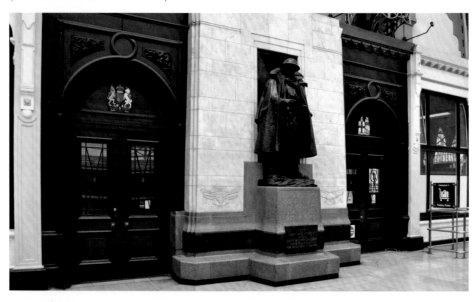

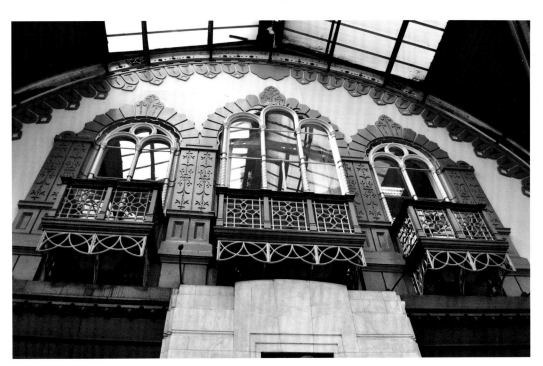

## Directors' Room and Royal Waiting Room

Situated at the end of one of the crossways transepts, the balcony of the Directors' Room looks out across the busy platforms. Its three oriel windows are embellished in a Moorish style, and originally there was an entrance where the memorial is now located. Situated to the left of the memorial is the doorway leading to the Royal Waiting Room, shown in the 1890s photograph. (STEAM Museum of the GWR)

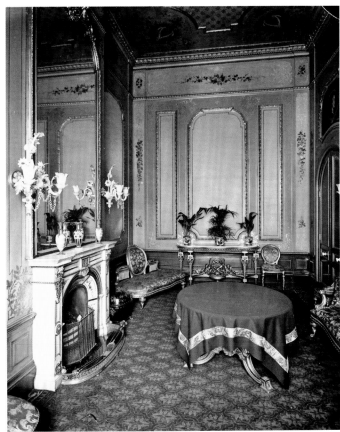

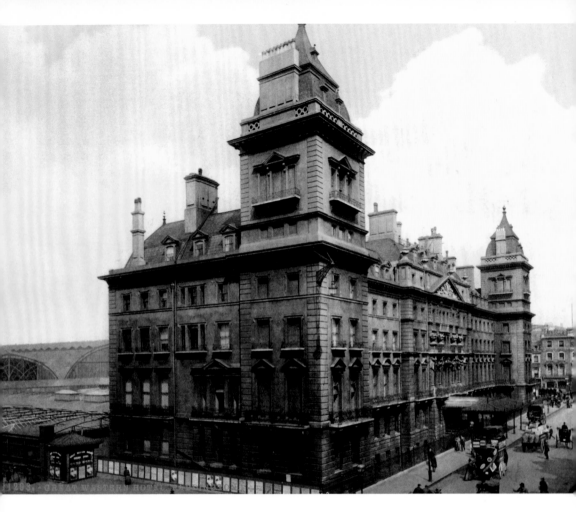

**Great Western Royal Hotel**

As Paddington is a station with no recognisable façade, the Great Western Royal Hotel on Praed Street was intended as a bold architectural statement to announce its presence. Brunel had no hand in its design, which was undertaken by Phillip Charles Hardwick, and the result is an imposing building with two corner towers in the French Second Empire Style. Opened in 1854 and although managed separately from the railway initially, its first chairman happened to be Brunel. The hotel saw a major refurbishment in the 1930s which included new interiors in the Art Deco style and tidying up some of the external Victorian ironwork.

*Opposite page:* The hotel was extensively updated in 2001 and today it is known as the Hilton Paddington Hotel.

34

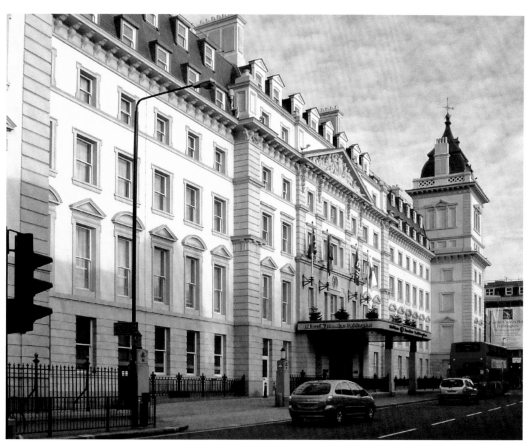

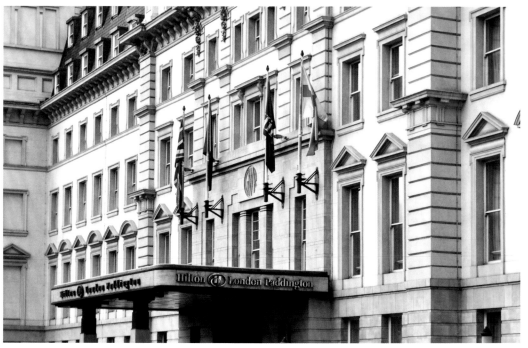

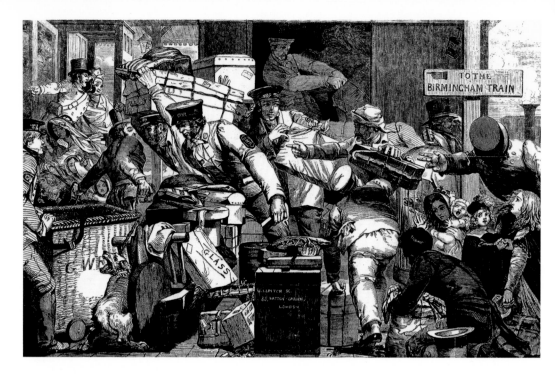

## The broad gauge problem

Brunel's greatest innovation for the GWR was his insistence on the broad gauge track width of just over 7 feet. Undoubtedly superior in many respects to its narrower rival adopted by the other railways, the so-called 'standard' gauge, there were inevitable problems where the two gauges met head on. Passengers and goods had to be transferred from one train to the other as epitomised by this contemporary scene of the chaos at Gloucester station. The broad gauge lost out by sheer weight of numbers, and on 20 May 1892, the *Cornishman* became the last broad gauge departure from Paddington's Platform 1.

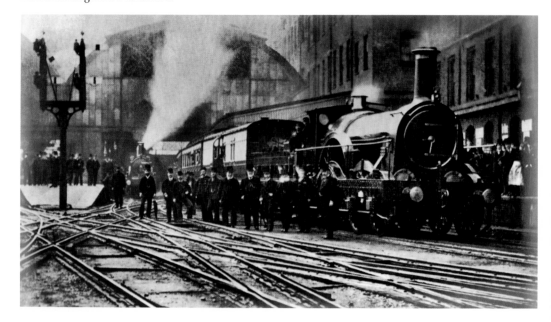

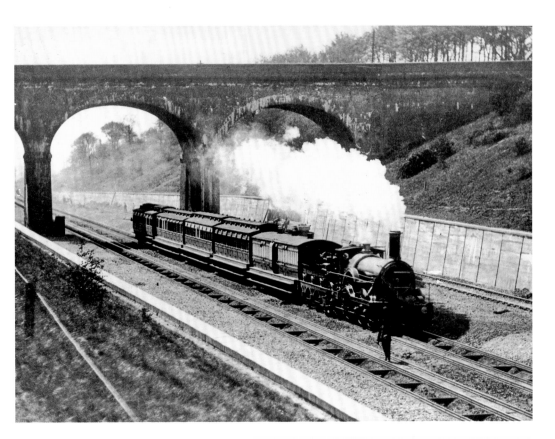

## Broad gauge farewell

Heading west, the final broad gauge train poses for a photograph in Sonning Cutting, 20 May 1892. By the end of that weekend, the last of the track was converted to standard gauge in a mammoth operation involving thousands of men. *Punch* marked the 'Burial of the Broad Gauge' with a full-page illustration of the ghost of Brunel walking beside its grave:

Lightly they'll talk of him now he is gone,

For the cheap 'Narrow Gauge' has out-stayed him,

Yet BULL might have found, had he let it go on,

That BRUNEL'S Big Idea would have paid him!

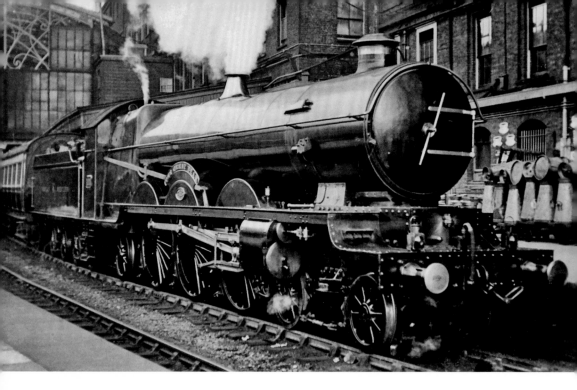

**Steam departures**
Platform 1, with the gabled end of the station roof in the distance and the dark brickwork of the Eastbourne Terrace buildings, has provided a common backdrop to a succession of locomotive types over the years. Above is the 4-6-2 Pacific No.111 *The Great Bear* from around 1910, which was withdrawn in 1924 and rebuilt as the 4-6-0 *Viscount Churchill*. (STEAM Museum of the GWR) Below is Class 4-6-0 6024 *King Edward I* bringing steam back to Paddington in December 2004. (James Lawrence)

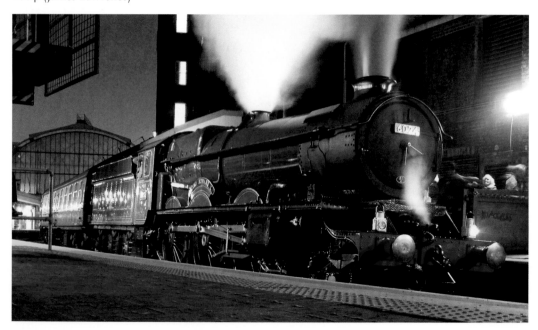

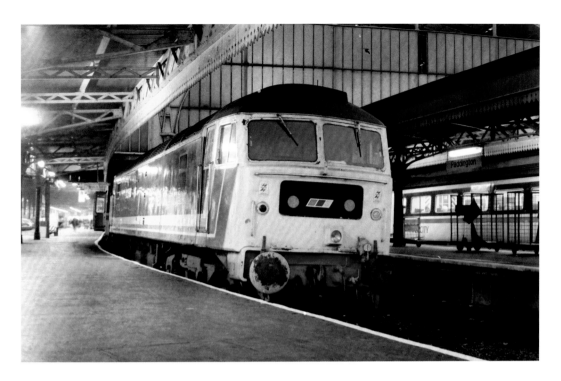

Diesel power

Class 47 diesel 47530 in British Rail livery, photographed on Platform 8 in 1989. (Michael Hill) Below, a Class 43 High Speed Train (HST) operated by First Great Western and photographed standing at Platform 1 in May 2010. The fastest diesel locomotives in the world, the Class 43 have an absolute maximum speed of 148 mph. In contrast to its sleek modern lines, note the dirty condition of the old platform awnings.

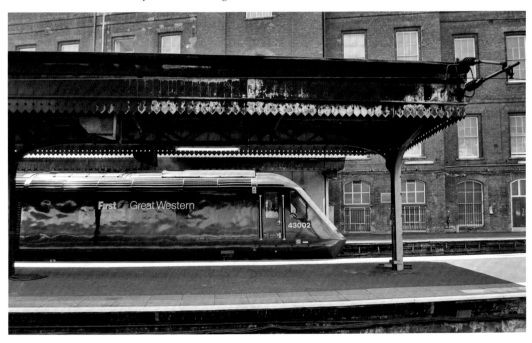

# Twentieth-Century Expansion

As one of London's busiest working stations, Paddington has undergone several periods of expansion and modernisation. This was particularly so in the early twentieth century when an ever-increasing volume of passenger and goods traffic began straining existing facilities to the limit. It is estimated that by 1907 around 300 trains were leaving the station every twenty-four hours.

In 1904, a plan was put forward including the addition of a fourth roof span to accommodate several new lines and platforms; the replacement of the old multi-arched Bishop's Road Bridge with a steel girder bridge to allow greater flexibility in the positioning of the tracks; extending the platforms at the 'Country' end; plus various new buildings and improvements to existing facilities in and around the station. In preparing for the new span, the structural engineers discovered that the existing third span had been pushing outwards and was several inches out of true. In addition, Brunel's slender iron roof pillars were also found to be under considerable strain. Constructing the new span served to shore up the original roof on the northern side, and the original pillars were replaced with more substantial steel ones in a process that was only completed in 1928. As part of the fourth span construction work, additional platform and storage space was created by excavating beneath London Street, which runs along its side.

With the station's footprint increased, the 1920s and 1930s saw a concerted effort to modernise what the Victorians and Edwardians had bequeathed. A new company office block, designed by P. A. Culverhouse in the latest angular Art Deco style, replaced some unremarkable earlier buildings on the arrivals side roadway. Its lower floor housed the station buffet opening out into the re-roofed Lawn area, which had been cleared to create a more defined circulating space linking the departure and arrival sides of the station. The booking hall and passenger information systems were also upgraded, and new entrances leading down to the Underground stations were added.

The Great Western Royal Hotel was given a timely makeover, involving revamping interiors and removing some of the exterior Victorian ironwork, while the new GWR 'shirt-button' roundel began to make an appearance on buildings, publicity material and even company uniforms. You can still see it on the front of the hotel and set into the ground at its entrance. There were also ambitious plans to replace the office buildings running along Eastbourne Terrace with a new super hotel, but these did not come to fruition due to a downturn in the economy in the 1930s.

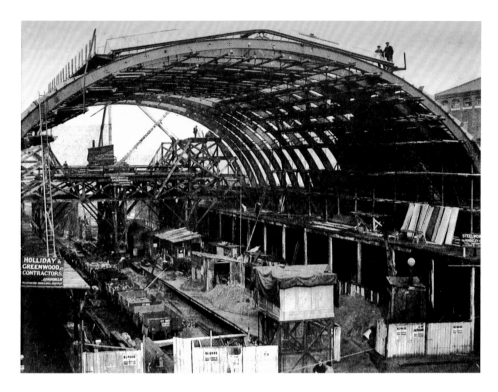

### Adding the fourth span

Construction of the fourth span on the north side of the station began in 1913 and was completed in 1916. (Network Rail) Designed by the GWR's engineer W. Armstrong, it largely mimics Brunel's originals, although its sixty ribs are made of steel-plate girder rather than iron. The end of the span nearest to the sloping Arrivals Road is tapered to accommodate the shape of the site.

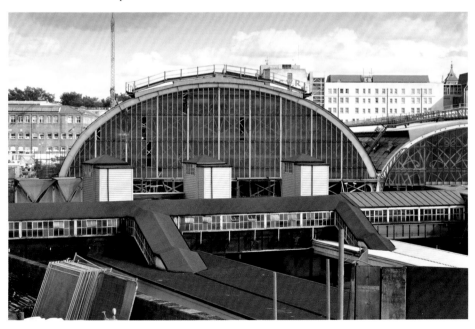

## Improvements and alterations in the 1930s

These drawings of the station layout were originally published in *The Railway Gazette*. Packed with information, they show the station and lines as they were in 1929, and again after the numerous alterations were completed in 1933. On the northern side, Bishop's Road Station has been enlarged with improved footbridge and access from the main station, including a new booking office on a raised level at the end of Platform 8. Right across the station, the platforms have been further extended, there is a new parcels receiving depot, plus an enlarged parcels platform and cartage area at the end of Platform 1 running under the Westbourne Terrace bridge.

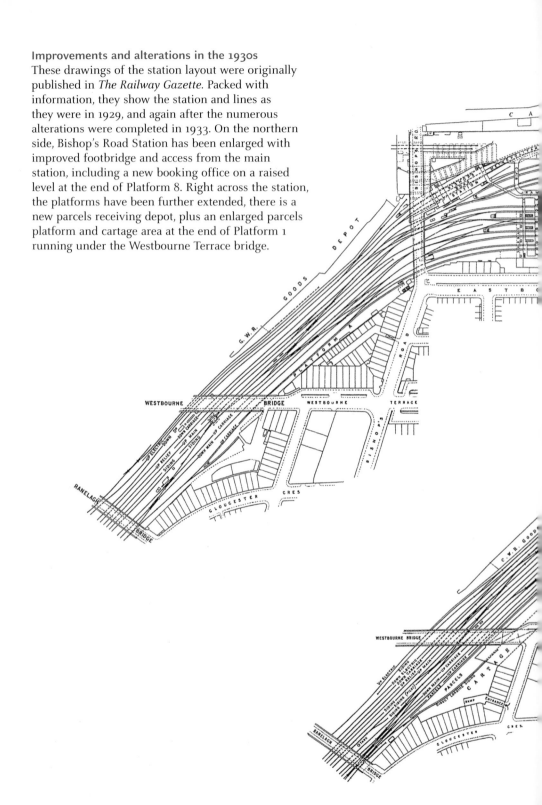

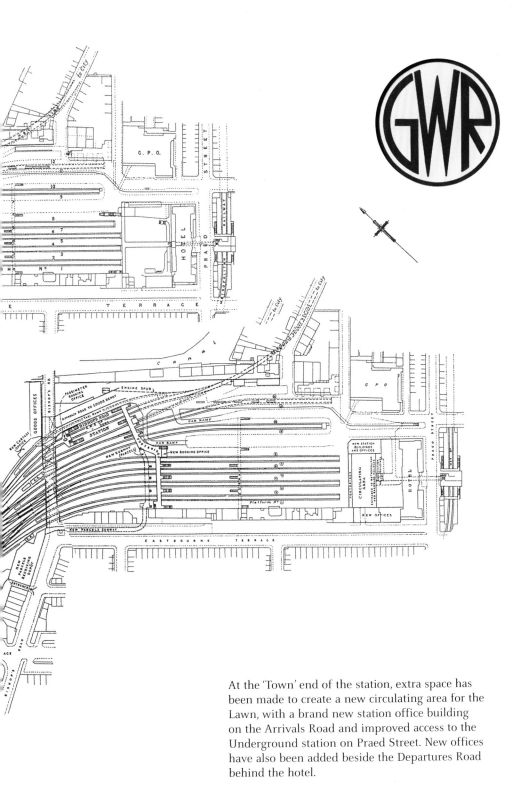

At the 'Town' end of the station, extra space has been made to create a new circulating area for the Lawn, with a brand new station office building on the Arrivals Road and improved access to the Underground station on Praed Street. New offices have also been added beside the Departures Road behind the hotel.

### Spanning the years

Span 4, with its GWR coat of arms, has become such a familiar sight that it is hard to believe that until recently it was under threat of demolition. Seen from the third span, it was shrouded in scaffolding during a major restoration which started in 2010.

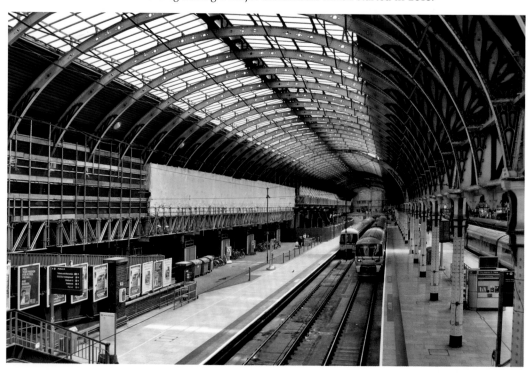

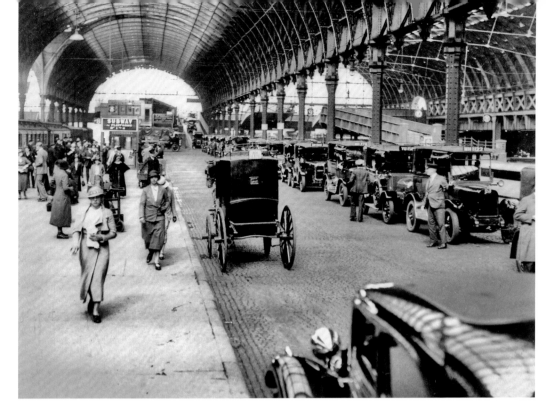

Comings and goings

Looking through the third span into the fourth, in 1934, with over twenty motorised taxis waiting plus a lone horse-drawn taxi in the centre of this picture from the STEAM Museum of the GWR. Until recent times the taxis used to enter the station via a ramp leading from London Street on the north side and exit up the Arrivals Road to Praed Street.

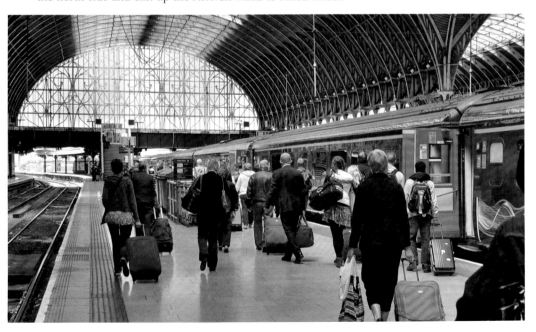

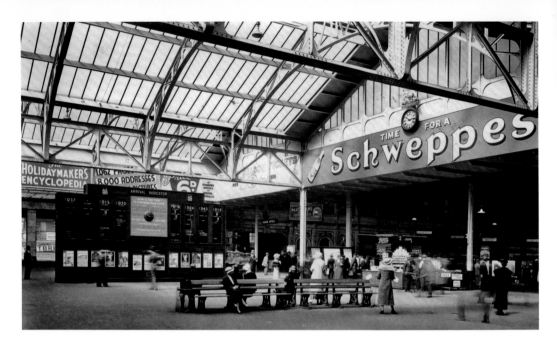

## The Lawn

In the 1930s, the Lawn area was remodelled by the company architect P. E. Culverhouse to create a natural circulating area for travellers. It is thought the name comes from a garden that once stood on the site. The Train Indicator board was installed in 1934 to show train arrivals and departures (on the other side). The mechanism was built by Siemens Ltd and used a primitive computer system with stored data called up by an operator in one of the GWR offices.

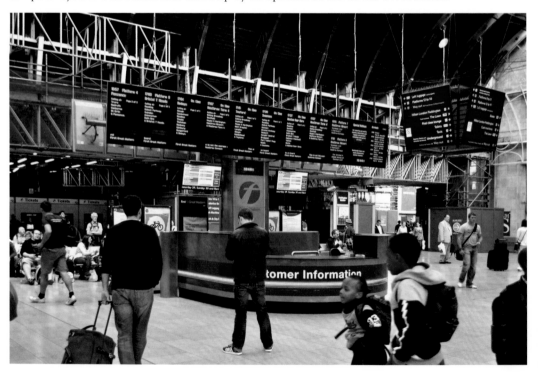

## Just the ticket

Plastered with travel posters, in the 1930s the new No.2 Booking Hall was considered the height of modernity, and behind the scenes, a special department printed the card tickets to every destination in the GWR network. Today, John Doubleday's statue of Brunel gazes out into his station, his back to the Departures Road entrance, while travellers feed little plastic cards into automated ticket machines.

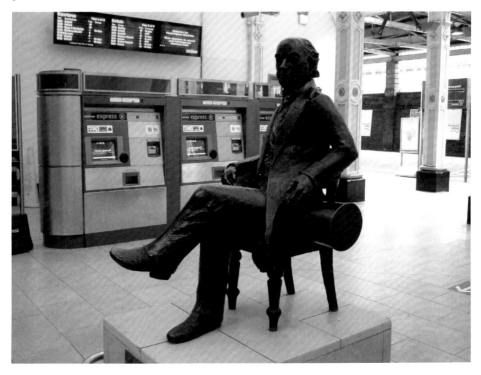

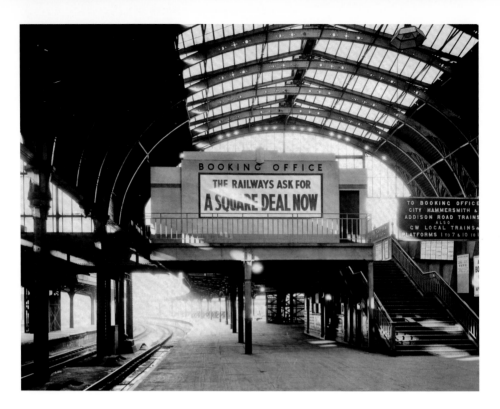

## Booking Office

A newly opened booking office, added in the 1930s, was placed at the end of Platform 8 on the raised level leading to other platforms and the footbridge for the old Bishop's Road Station, shown below. The sign reads, 'To Booking Office, City Hammersmith & Addison Road Trains, also GW local trains ...' The banner for 'A Square Deal Now' was part of a campaign waged by the four big railways for fairer government treatment against the growth of road transport.

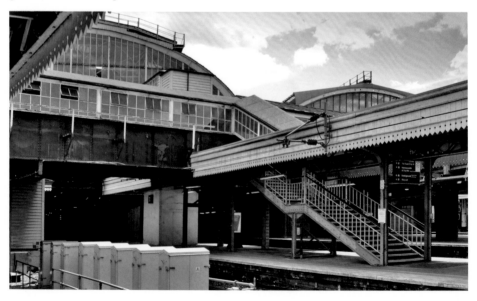

### Extending the platforms

This postcard of the 4-4-0 locomotive *Stanley Baldwin* starting out from Paddington's large central span shows the end of the station before the addition of platform canopies. The platforms were extended in the 1930s, using pre-cast concrete sections for easy assembly, with awnings added to protect passengers from the weather. Standing over this group of modern HSTs, their frilly edges seem a somewhat archaic throwback to the past, more suited to a country station than the GWR's flagship terminus.

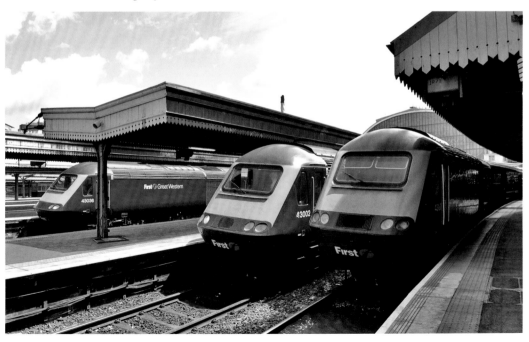

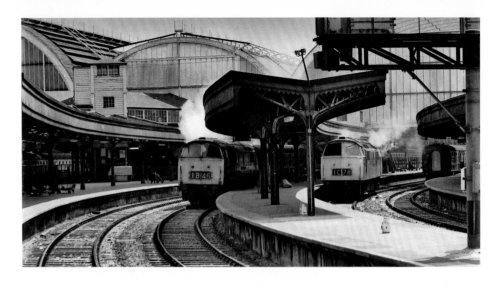

## A view from the bridge

A pair of British Rail Class 52 Westerns amid the old platform awnings. These diesel locomotives, with their distinctive curved rooflines, were built between 1961 and 1964. Below, all four spans seen end-on with the additional Edwardian span to the left and Brunel's original three to the right. Looking back from Bishop's Bridge, the platforms are numbered from right to left starting with Platform 1 on the far right.

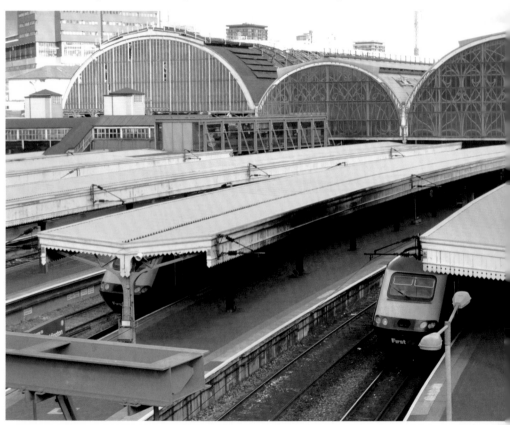

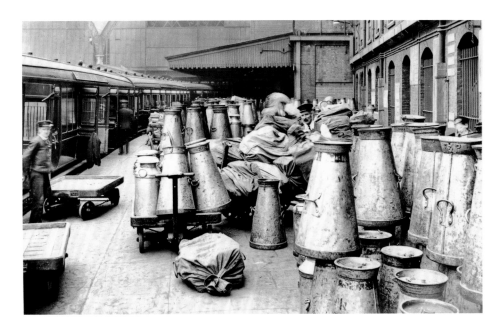

Porters sort the empty milk churns on Platform 1, *c.* 1914. Thousands of gallons were needed to supply Londoners and it is estimated that in the 1920s the station was handling 5,500 churns every single day. (STEAM Museum of the GWR)

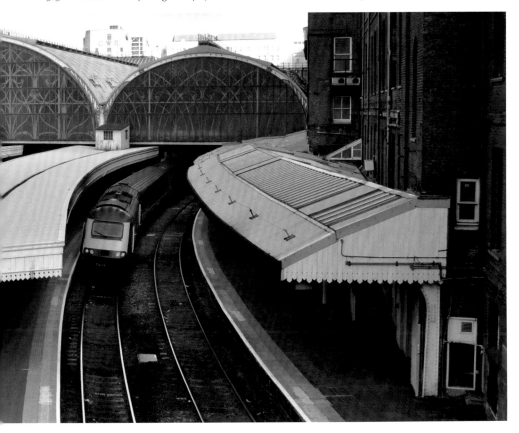

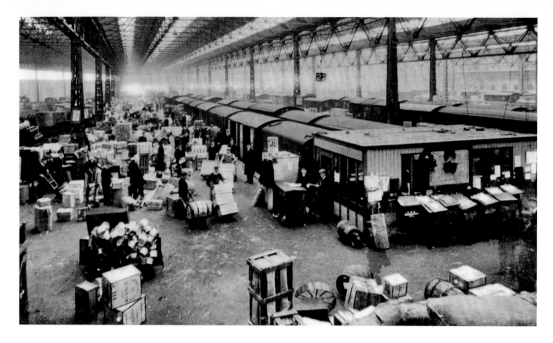

## Moving the goods

Located on the site of the original Paddington Station, on the north-west side of Bishop's Bridge Road, in a triangle of land bordered by Harrow Road and the Grand Junction Canal, the GWR's Goods Department was vast in its heyday and employed almost 2,000 members of staff by the 1930s. The decline in goods traffic in modern times has seen its demolition. This valuable building plot is now occupied by the Sheldon Square complex, which offers high-spec office space and trendy residential apartments. Very handy for the station.

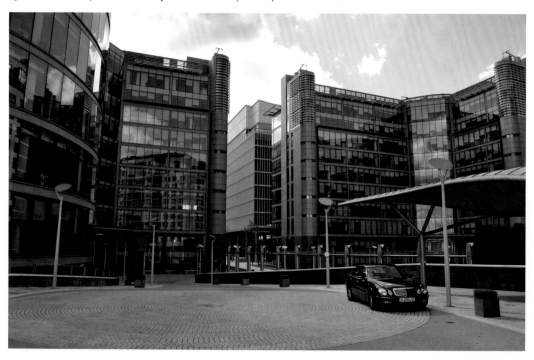

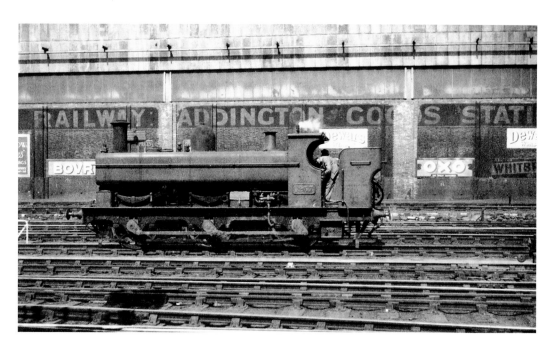

## The Goods Department

All that remains of the former Goods Department is the retaining brick wall which became a familiar backdrop for countless train photographs. A GWR 0-6-0 Class 1076 tank engine is shown above with the writing on the wall. Sometimes known as the Buffalo Class, these were designed by Joseph Armstrong and built between 1870 and 1881, with some examples working until 1946. This particular loco, No.1257, was built in 1877, had pannier tanks fitted in 1919 and operated until 1930. The more recent picture shows a modern suburban train against the truncated brickwork.

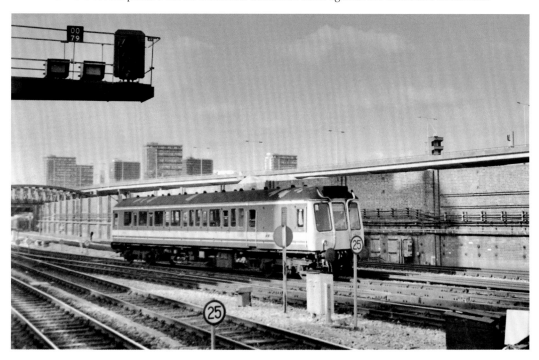

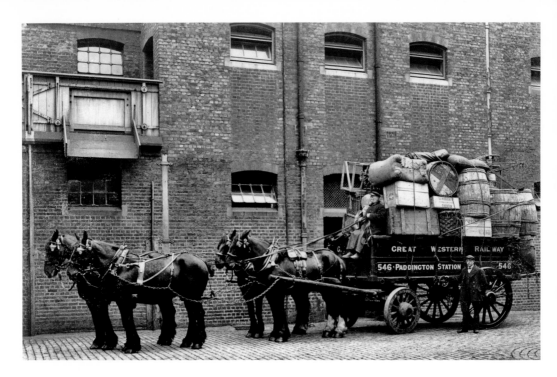

## Horse power

It was vital that the goods were delivered quickly from the depot to their final destinations, especially when it came to fresh food items such as fruit or vegetables. To accomplish this task, the GWR had a huge fleet of horse-drawn vehicles, although by the Second World War, they had largely been replaced by motor vehicles. More than 500 company horses were accommodated in the Mint Stables – named after the pub which had previously stood on this site – a three-storey brick building which was fitted with special access ramps. The building still survives on London Street, across the road from Paddington's Fourth Span, as part of the St Mary's Hospital complex.

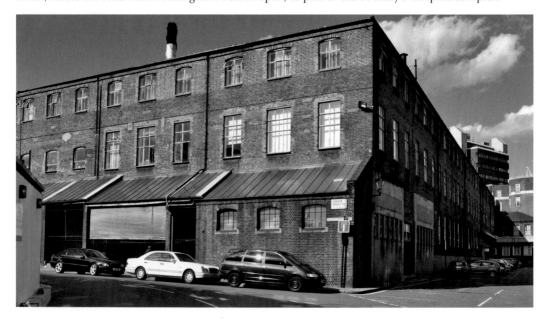

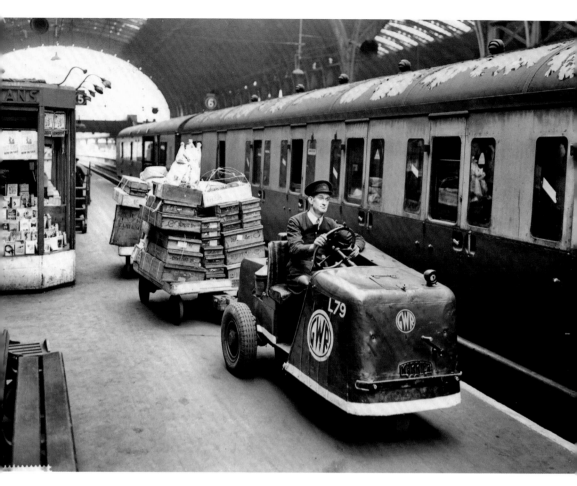

## Mechanisation

Inevitably mechanical power came to replace the horses and, to some extent, the army of railway porters. This petrol-driven Karrier is moving parcels on Paddington's Platform 5. (STEAM Museum of the GWR) The three-wheeler tractor layout was also adopted by Scammell for their appropriately named Mechanical Horse road vehicle, which was produced from 1933 onwards and featured a boxy-looking wooden cab. This was superseded by the more powerful Scarab, shown right, manufactured from 1948 right up until 1967. The example on display at Swindon looks superb in the GWR cream and brown livery, but it is questionable whether this is authentic, as the railways were nationalised on 1 January 1948.

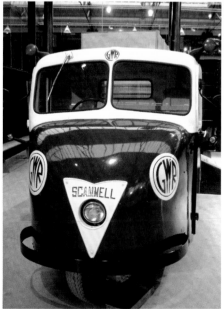

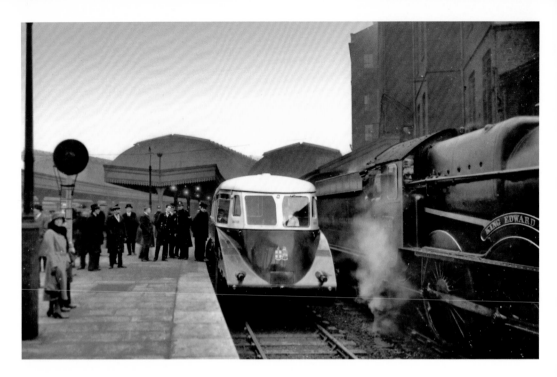

### The shape of things to come

On 1 December 1933, the GWR Diesel Railcar No.1 was surrounded by members of the press before it departed from Platform 2, dwarfed by the No.6001 *King Edward VII* steam locomotive standing alongside. (STEAM Museum of the GWR) At the time, its bodywork was described as 'air-smoothed' although its detractors labelled it as the 'flying banana'. In truth, the more aerodynamic shape anticipated the High Speed Trains of today. The early Railcars were powered by an AEC 130-hp 'heavy oil' engine. Some later models were equipped with buffets and even a loo.

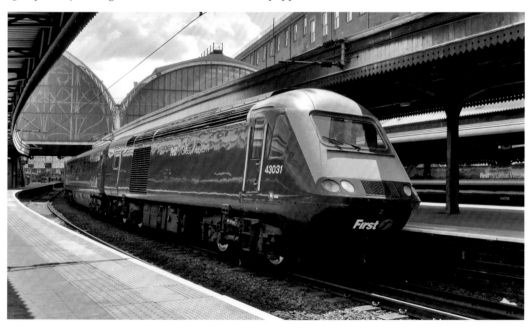

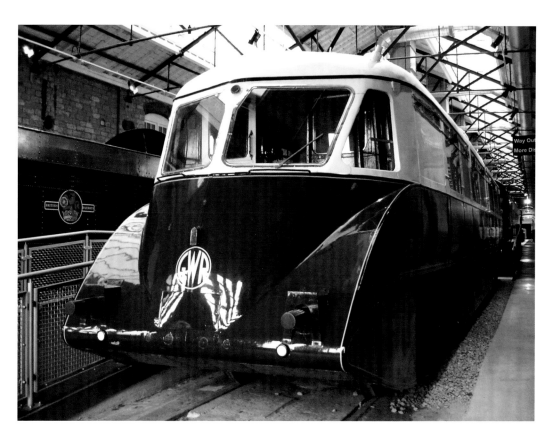

Thirty-eight Railcars were built until production ceased in 1942. Many continued in regular service until the 1960s, when larger diesels were introduced. The preserved No.4 is on display at the Swindon museum, while this contemporary postcard shows the shiny new No.1 at Southall Station.

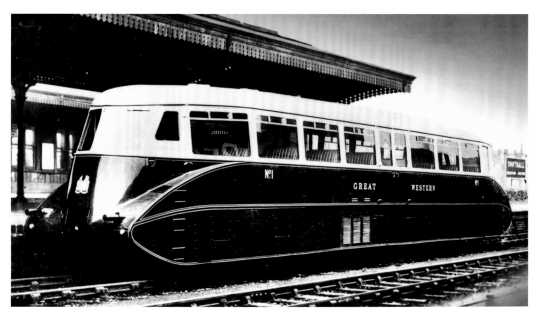

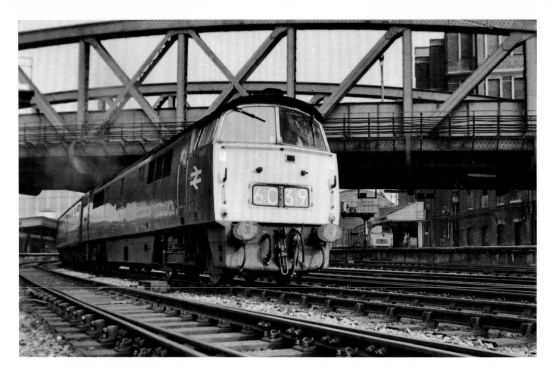

## Bishop's Bridge

The Edwardian steel girder bridge which carried Bishop's Road across the tracks immediately north of the station became an integral part of Paddington landscape in itself and has appeared in countless enthusiasts' photographs over the years. In this 1970s shot of a departing British Rail Class 57 Western, the station can be seen beyond the bridge. Its modern replacement may lack the character of its predecessor, but it still frames the same view of Paddington's famous roof.

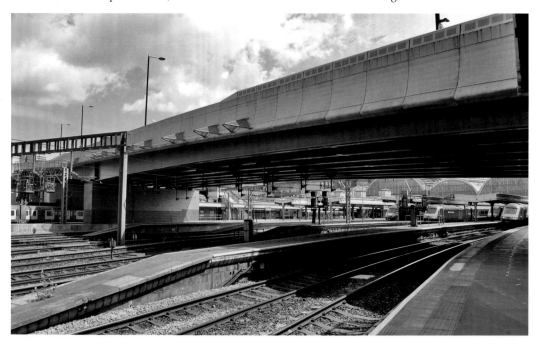

## Beneath the new bridge

By the 1990s, it was clear that the old Bishop's Bridge was coming to the end of its useful life. The steelwork was beginning to crumble and it had become a notorious bottleneck for traffic. Under the northern side of the bridge, little evidence remains of the earlier structures, as seen from the platforms of the former Bishop's Bridge Station.

### Replacing the Edwardian bridge

To avoid disruption to the railway traffic, the Edwardian steel bridge was raised on jacking towers to allow for the replacement of the sub-structures, then the new 2,500-ton concrete slab was rolled into position beneath it. The old bridge was lifted in August 2004 and the new deck put in place in 2005. This photograph shows that the old bridge spanned only ten of the tracks and rested on an intermediate masonry pier, with a masonry bridge carrying the road above the lines running into the old Bishop's Bridge Station (at the bottom of the picture) and over the canal on the northern side. It was during the demolition of this section that Brunel's original 1839 iron bridge over the canal was discovered, obscured for years by later rebuilding work. (Dorman Long Technology Ltd)

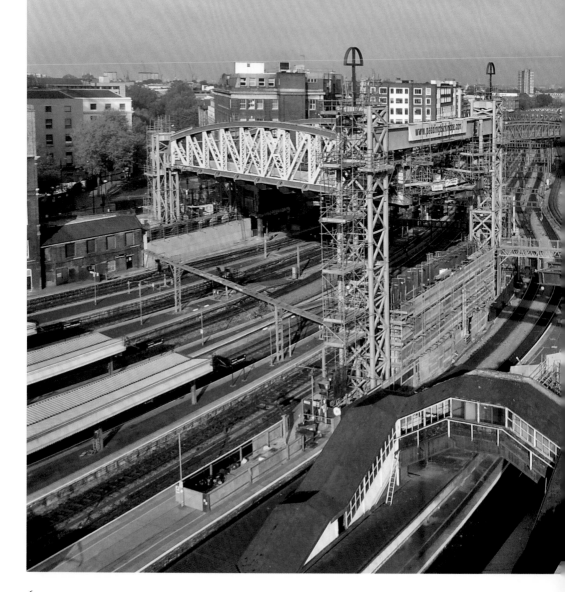

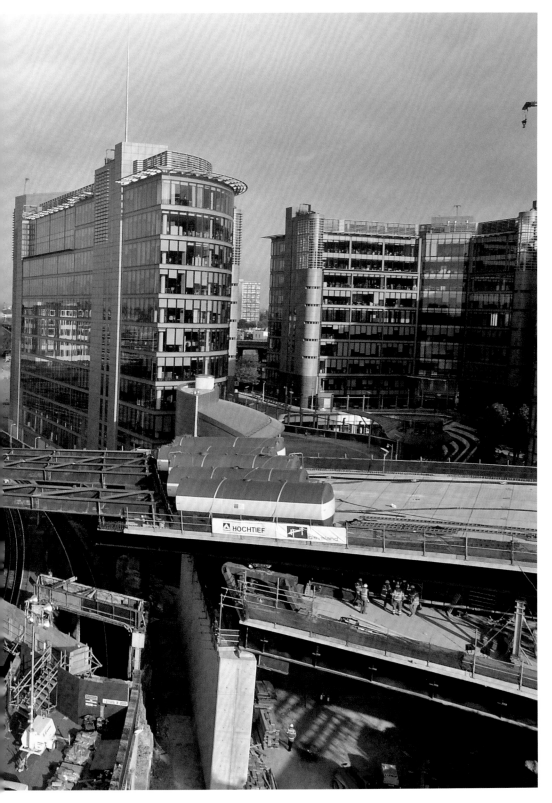

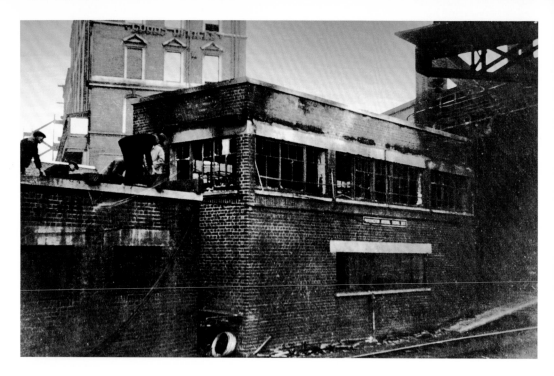

**Arrivals signal box**

This was situated at the end of Platform 10, tucked beneath the intermediate pier of Bishop's Bridge. In the photograph above, workers are starting repairs following a fire in November 1938. Note the GWR Goods Office, in the background, which stood on the north side of Bishop's Road. Both structures are gone now, although the signal box was still standing in the 1980s when this British Rail diesel was passing through.

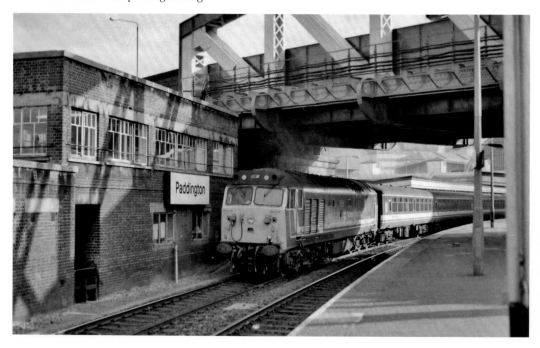

### Tournament House

Completed in 1935, Tournament House replaced a collection of low-level buildings beside the Arrivals Road to provide additional office space on the upper storeys and a new buffet and tea room opening out onto the Lawn at ground level. Designed by company architect, P. A. Culverhouse, this steel-framed office block is a striking example of the Art Deco style. It features shallow oriel windows incorporating ventilation vents and, at the top, a series of shell-shaped uplighters illuminate the bold lettering proclaiming 'GWR PADDINGTON'.

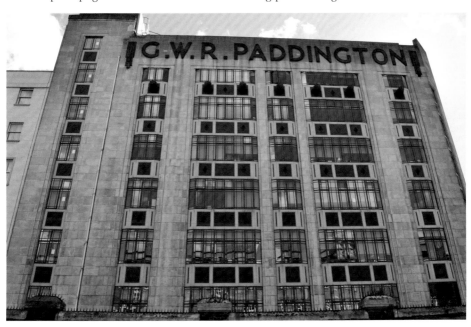

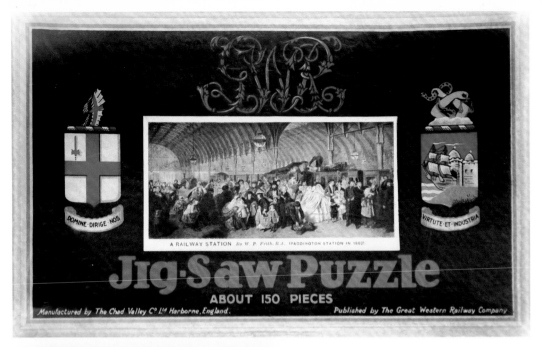

A RAILWAY STATION By W. P. Frith, R.A. (PADDINGTON STATION IN 1862)

Jig·Saw Puzzle
ABOUT 150 PIECES

Manufactured by The Chad Valley Cº Lᵈ Harborne, England.   Published by The Great Western Railway Company

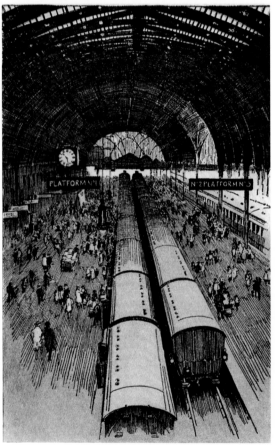

## Merchandise and branding

Of all the big four railway companies, the GWR was known for its publicity material, including a series of self-published books and all manner of items which we would now term as merchandise. Paddington was at the heart of the company and its four spans became the instantly recognisable masthead on the *GWR Magazine*. The station also appeared on jigsaws, such as this example from the 1920s of Frith's famous painting, and in the highly popular guide books, such as the long-running *Through the Window – Paddington to Penzance* (shown left).

## Hotel refurbishment

In the 1930s, the Great Western Royal Hotel underwent the first major refurbishment since its construction. With Victorian architecture decidedly out of fashion, Hardwick's grand rooms gave way to new Art Deco interiors lined with flush polished panelling. In similar manner, the exterior was cleaned up of its Victorian clutter, the old cast-iron porch was removed and the lower storeys refaced in stone. Most notably the new GWR 'button' logo, or roundel, made its appearance on the façade and set into the ground in front of the entrance.

# Paddington's Other Stations

Paddington's position within a cutting made it ideally placed to connect with London's new underground railways, particularly the sub-surface Metropolitan Railway which obtained Parliamentary assent in 1853. The western-most terminus for this line was the Bishop's Road Station on the northern corner of Paddington. Opened in 1863, the mixed-gauge track was worked as a joint venture between the GWR and the Metropolitan Railway. The following year, services were extended westward to the GWR's Hammersmith branch, and in 1867, this line became the Hammersmith & City Railway and was also used by GWR suburban trains. A footbridge linking with Paddington was added in 1870, and by the mid-1930s, Bishop's Road Station became known simply as Paddington with the platforms designated as Nos 13-16.

The Metropolitan Railway's other station at Paddington has a much higher profile thanks to its independent frontage on Praed Street. The station, designed by the Metropolitan's engineer Sir John Fowler, had a pedestrian subway connecting with Paddington added in 1877, and a new two-storey façade was applied to the entrance building in the 1920s.

Far deeper than the Metropolitan's sub-surface line is the Bakerloo Line. Originally known as the Baker Street & Waterloo Railway, it is, arguably, Paddington's only true underground and the station opened in December 1913. Access was via a series of escalators, the longest ever constructed at the time.

Paddington was also the terminus of the Post Office Underground Railway, or Mail Rail, running eastwards to the Whitechapel Delivery Office from 1927 until 2003. At its peak, it had nine stations on twenty-three miles of track governed by a computerised control centre. Labelled by the press as the 'Robot Railway', its driverless trains ran on a narrow two-foot gauge, moving an average of four million items of post every day.

Above ground, the first stop out of Paddington is Royal Oak, less than a mile away. This opened in 1871 for passengers on the GWR main line (until 1934) and also for those on the Hammersmith & City Line. Next out is Westbourne Park, opened by the Metropolitan Railway in 1866. It now serves the Circle Line and the Hammersmith & City Line running southwards. In addition to its stations, the GWR required facilities for the maintenance of locomotives and Old Oak Common, in South Acton, became a loco depot from 1906 onwards and remained largely intact until diesel power replaced the steam trains. In 1908, an additional outstation depot, where locomotives could be turned, coaled and watered, was established at Ranelagh Bridge in a triangle of land on the opposite side of the tracks to Royal Oak Station.

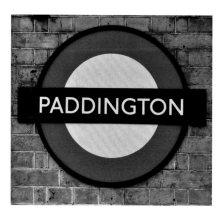

## More than just the GWR

This Railway Junction diagram of 1912 illustrates how London's railway network became ever more complicated with its myriad of interconnections between the different lines. Paddington is indicated at the top as 'G.W. Pass' with the Great Western line in yellow. Other stations in the vicinity include Praed Street, Bishop's Road, Royal Oak and Westbourne Park, but not the Bakerloo Line station, which didn't open until 1913.

## Going Underground

Paddington is served by several Underground lines including Bakerloo, Hammersmith & City, the Circle and the District Lines, and their assorted stations, including Bishop's Road and Praed Street, are known simply as Paddington. The iconic London Transport wheel-and-bar roundel has its origins with the London General Omnibus Company in the nineteenth century, and it was adopted by the Underground from 1908 onwards. Edward Johnson produced a standardised design in 1919, which has been universally applied to buses and the Tube ever since.

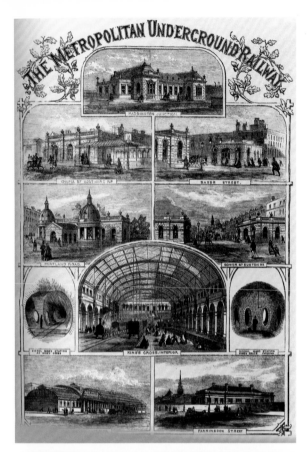

**London's first underground railway**
The Metropolitan Railway was not only the capital's first underground railway, it was the first in the world. Designed to connect the city with the growing number of railway termini, the GWR helped finance the scheme provided a junction was created with Paddington. The Act of Parliament was passed in 1854 approving the construction of a line between Paddington and Farringdon Street via King's Cross. With Sir John Fowler appointed as engineer, construction commenced in 1860 and the line to Paddington opened in October 1868. The station at Paddington is located on the south side of Praed Street directly opposite the Great Western Royal Hotel.

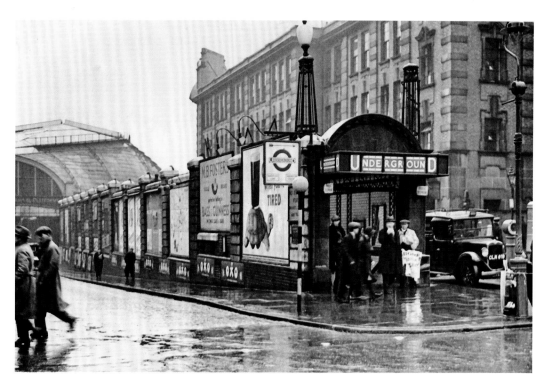

**Underground entrance from Praed Street**
The Underground entrance running alongside the Arrivals Road on the north side of Praed Street has changed little since this photograph was taken in 1937. The hump of the fourth span can be seen in the background, along with the imposing redbrick General Post Office building on the right. (TfL London Transport Museum)

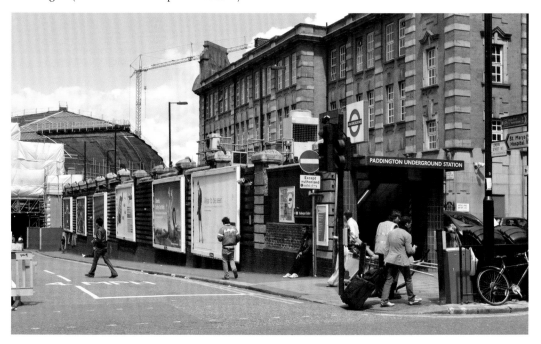

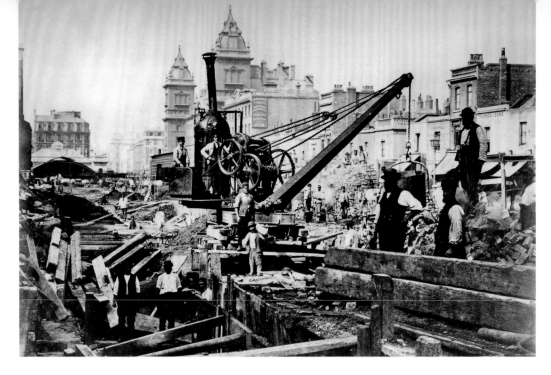

### 'Cut-and-cover' construction

The Metropolitan Railway was constructed using the controversial 'cut-and-cover' method. A trench was dug, then only partially covered over to allow the steam and smoke of the early locomotives to escape through the gaps. As can be seen from this view looking westwards down Praed Street, the excavations were incredibly disruptive. In the foreground, the navvies are using a steam-powered winch, and the towers of the Great Western Royal Hotel are visible in the distance. (TfL London Transport Museum)

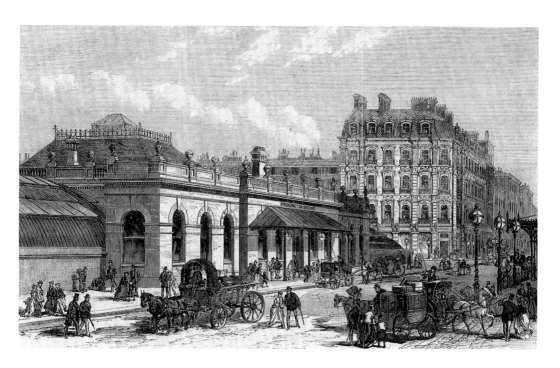

**Metropolitan Railway Station, Praed Street**
Originally designed by Sir John Fowler, the front of the single-storey Metropolitan Railway Station building on Praed Street was extensively restyled and enlarged in the 1920s with a second storey added. Note the lettering, 'Metroplitan Railway' and 'Paddington Station'. In the earlier image, the top of the glass roof is visible on either side of the station building, and the corner of the entrance portico of the Great Western Royal Hotel is on the far right.

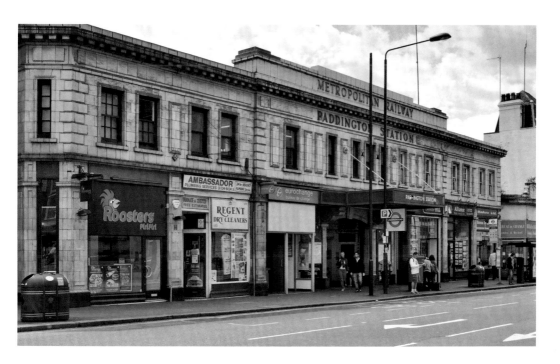

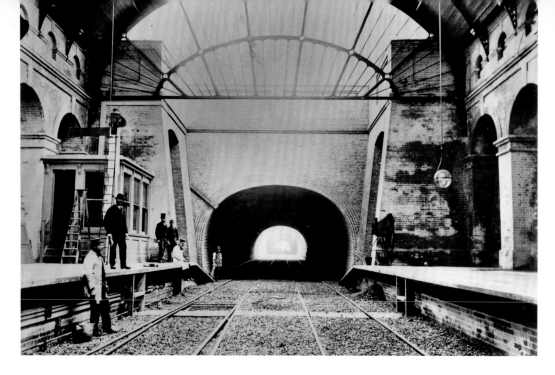

**Praed Street Underground**
Platform view at the Metropolitan Railway's Praed Street Station, looking towards Edgeware Road. This early photograph was probably taken shortly before the line to Paddington opened. Note the signal cabin on the left, the glass roof panels and the heavily buttressed and arched walls in warm yellow stock brick. The recent view is looking the other way beneath the two footbridges which connect the platforms. Known today as 'Paddington', the station is on the District and Circle Lines. (TfL London Transport Museum)

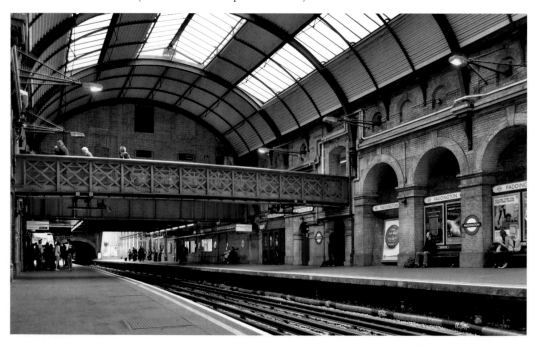

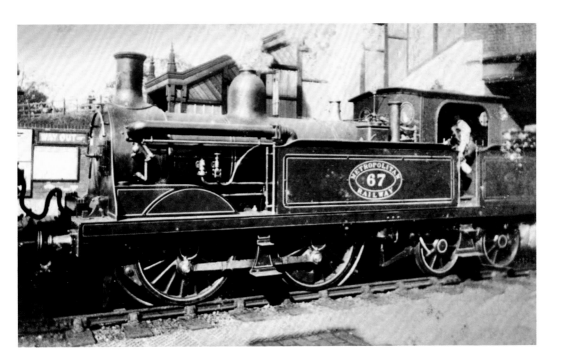

## Metropolitan steam

The first public trains to run on the newly opened Metropolitan Railway were hauled by broad gauge GWR Metropolitan Class condensing 2-4-0 tank engines designed by Daniel Gooch. However, these were soon superseded by the Met's own standard gauge locos in their distinctive burgundy livery. Locomotive No.67, an 0-4-4T, is shown in this image from the Collection of the National Media Museum, while the earlier No.23, a Metropolitan Railway Class A 4-4-0T is on display at the London Transport Museum in Covent Garden.

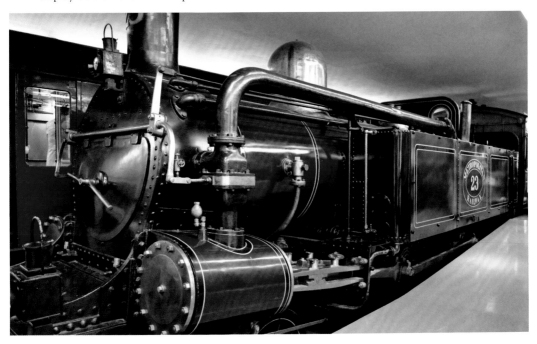

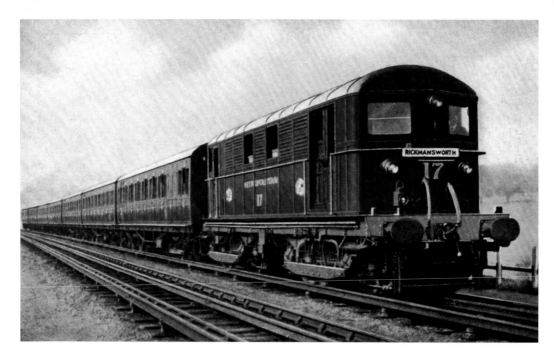

## Electrifying

The answer to the smoke and steam issue on the Underground was electrification, which enabled new lines to be dug far deeper than the sub-surface Metropolitan. To supply electricity to their network, the Met built its own power station at Neasden. This contemporary postcard shows Metropolitan Vickers Electric Locomotive No.17, with destination board for Rickmansworth, hauling 'bogie' stock coaches. The 1899-built No.400 coach is displayed at the London Transport Museum.

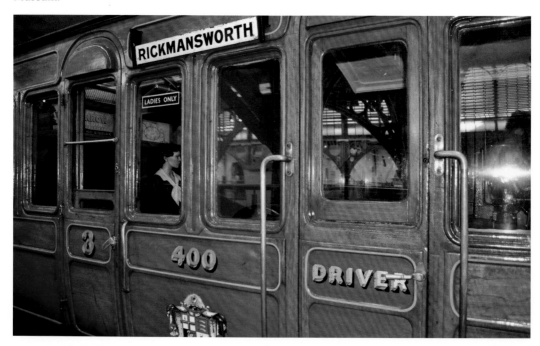

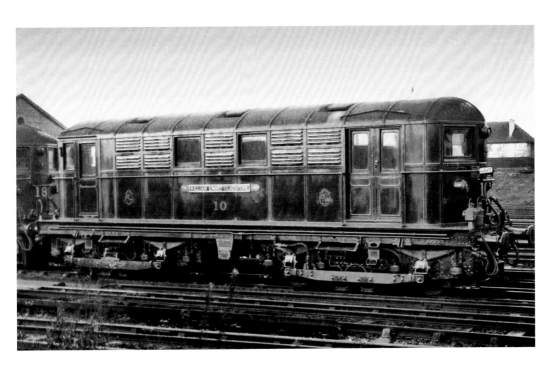

## Metro-land

No.10, the *William Ewart Gladstone*, carrying a destination board for Aldgate, stands in line with No.18. By the 1920s, the Metroplitan Railway had expanded out beyond London to serve not only the new suburbia of Neasden, Wembley Park, Pinner and Rickmansworth, but also destinations such as Harrow Garden Village in the commuter belt. Accordingly, the publicity department coined the term 'Metro-land'. Built in 1922, locomotive No.5 was named after the seventeenth century parliamentarian John Hampden and is now preserved in the London Transport Museum.

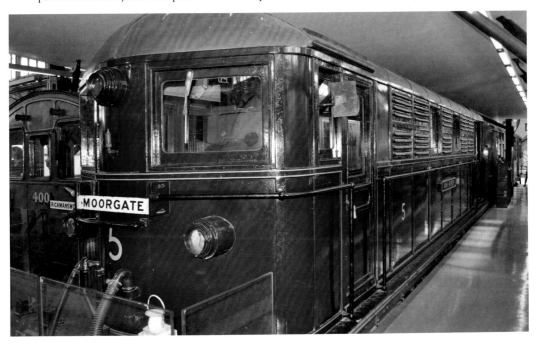

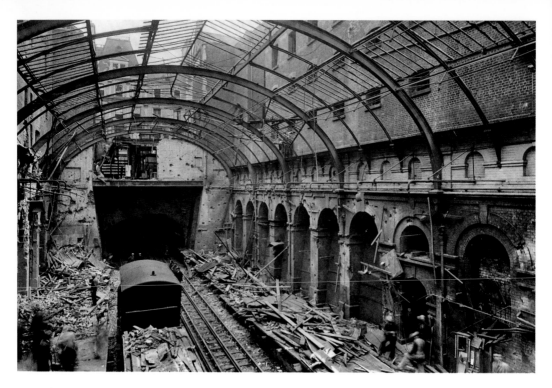

**Wartime bomb damage at Praed Street**
Both Paddington's main station and the Underground station on Praed Street suffered air-raid damage in the Second World War. In this photograph from October 1940, Praed Street Station is littered with debris from the arched roof. Six people died in this incident. (TfL London Transport Museum) The recent view shows that the roof has been shortened.

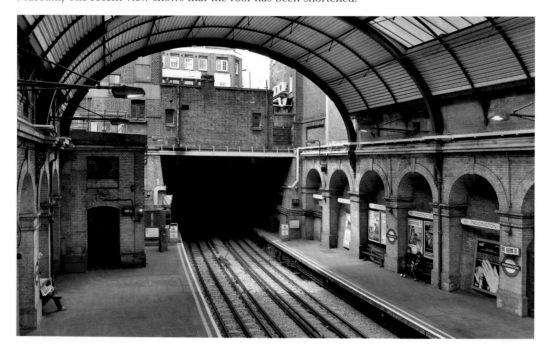

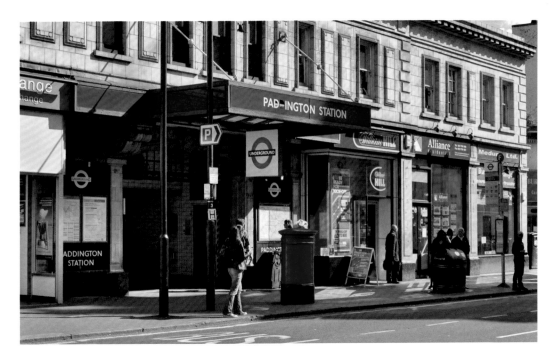

## Carrying on

As was customary with public buildings during the war, the entrance into Praed Street Station is protected by a brick 'baffle wall' in this 1944 photo. The roof of the canopy has been damaged and a replacement framework suspended beneath it. (TfL London Transport Museum) The defences have gone but not much else has changed except, curiously, that the station has a bigger pillar box nowadays.

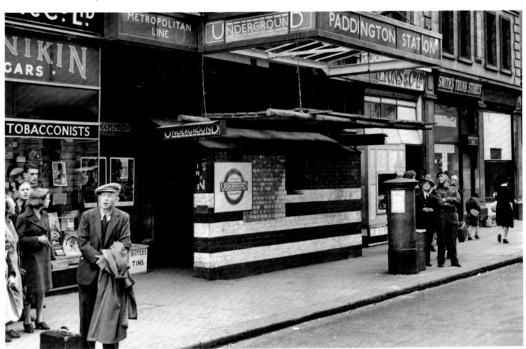

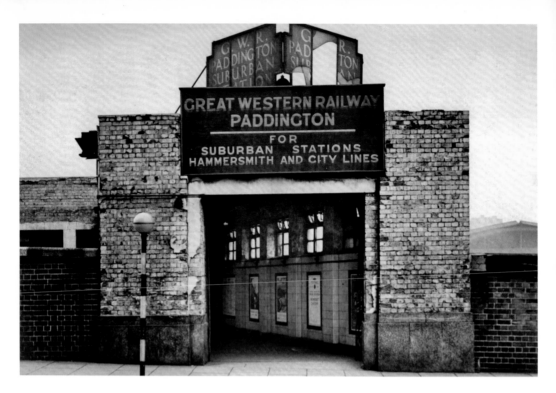

### Bishop's Road Station

There's nothing left of the old Bishop's Road entrance photographed in 1950 with its partially smashed signs. (TfL London Transport Museum) In 2010, this side of the station, from Span 4 all the way up to the bridge, was undergoing extensive building work for a new entrance and other facilities. The footbridge from the main station is still open.

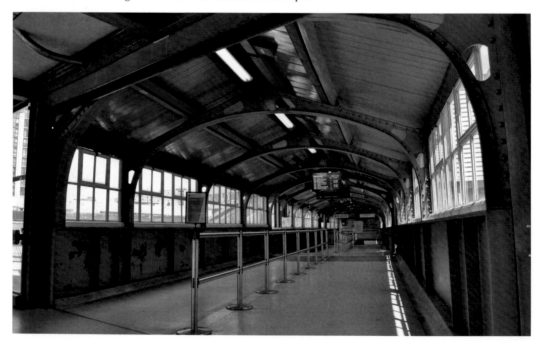

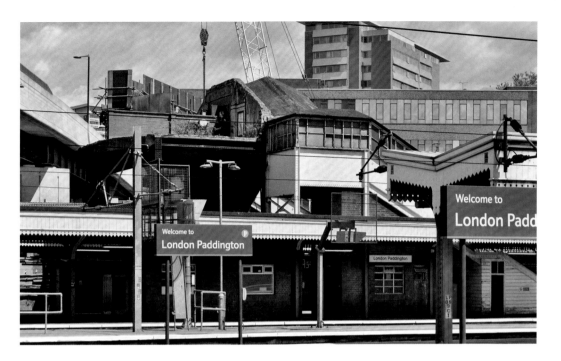

## Platforms 14 and 15

The platforms and passageway up to London Street from the former Bishop's Road Station, now Paddington's Platforms 14 and 15, shown in 2010. Some parts are being restored and others will be completely replaced. The lower view is facing north-west out of the station, with the second footbridge over the tracks and, in the distance, the remains of the Goods Depot wall. Looking upwards, the new Bishop's Bridge overshadows the old footbridge, and looming above the site is one of the new office blocks.

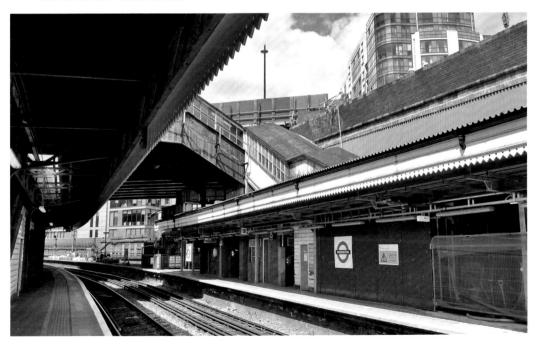

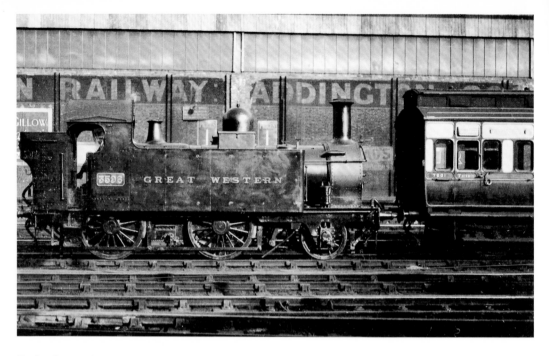

### Surburban trains

These 'Metro'-class 2-4-0T Pannier locos, built in the 1890s, were used extensively by the GWR on London suburban services. In this 1920s photo, No.3596 is hauling a Third Class carriage past the Goods Depot. The remains of the depot's retaining wall can be seen in the recent image of a modern suburban train amid the clutter of gantries on the approach into Paddington.

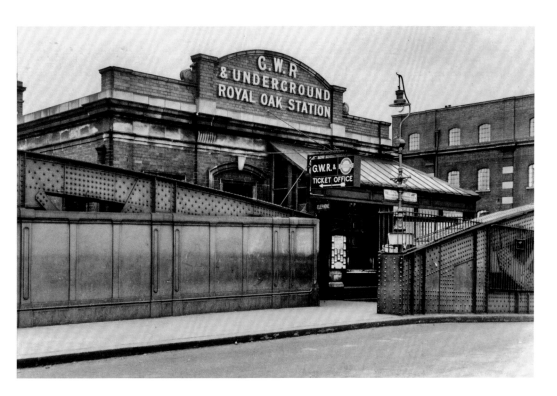

**Royal Oak Station**

Opened in October 1871, Royal Oak Station is thought to have been named after a nearby public house. The first stop out of Paddington for the GWR until 1934, it continues to serve the Hammersmith & City and Circle Lines. Situated on Lord Hills Bridge, the exterior has little changed, but not obvious in the photograph is the overbearing elevated section of the A40 Westway to the north. (TfL London Transport Museum)

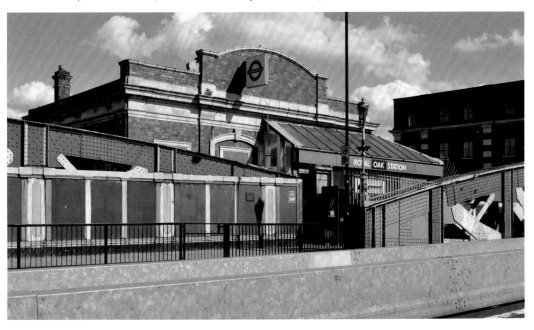

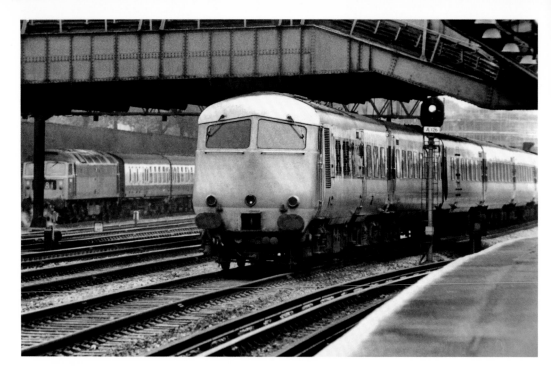

### Royal Oak and Lord Hills Bridge

A Bristol Pullman passing a Class 47 diesel held by signals at Lord Hills Bridge on the approach to Paddington. The Pullmans were the first luxury-class diesel-electric multiple units. Built by Metro-Cammell in Birmingham, they were introduced in 1960 and continued in use until 1973. (John Furnevel) The view from Royal Oak, looking back under the bridge, has little change except that the modern train of the Hammersmith & City Line lacks the Pullman's charm.

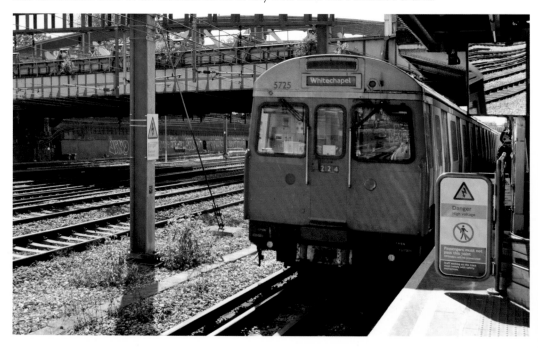

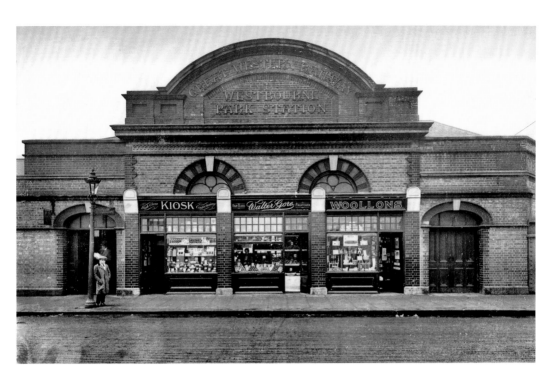

## Westbourne Park Station

Dipping under the main line and just to its south, trains on the Hammersmith & City Line arrive at Westbourne Park Station. There was a wooden-built station by this name from 1866, just to the west of the current location, but this was replaced by the new station in 1871. The writing on the brickwork at the front of the station once said 'Great Western Railway' and there were platforms for the main line here until 1992. (STEAM Museum of the GWR)

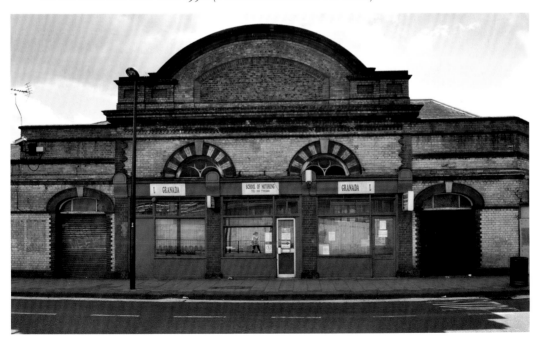

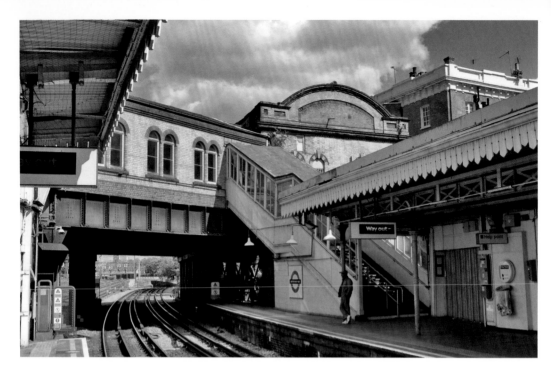

## Out of Paddington

Looking up to the back of the station building at Westbourne Park, with the line disappearing under the main line towards Paddington Station. The postcard, below, is a dramatic representation of a British Railways Western Region County Class 4-6-0 *County of Hereford* hurtling under the Ranelagh Bridge. Built in 1946 and scrapped in 1962, it represents the swansong of the glory days of GWR steam.

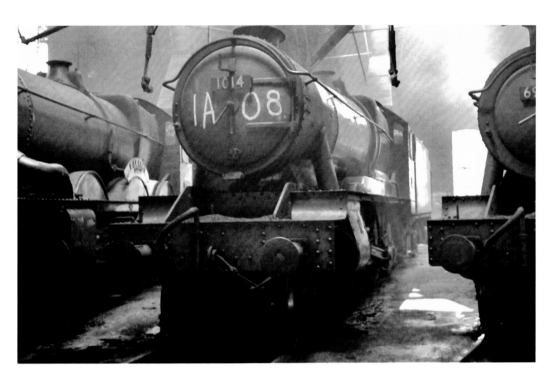

## Old Oak Common and Kensal Green

No.1014 *County of Glamorgan* in the roundhouse at Old Oak Common, South Acton, in July 1961. Once the GWR's main locomotive depot for London, today it is the Traction Maintenance Department for the storage and servicing of locomotives. (Keith Long) Just half a mile away and a stone's throw from the main line is Kensal Green cemetery where Brunel was buried in 1859. By coincidence, it is also the resting place of William Powell Frith who painted *The Railway Station*.

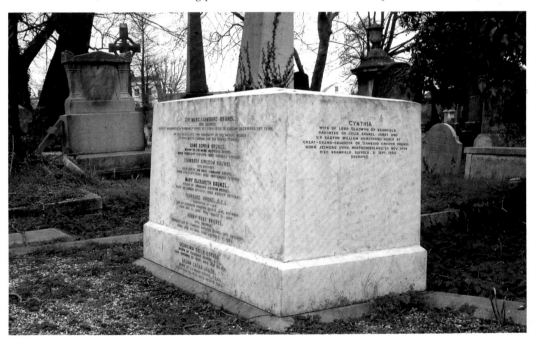

# New Developments

Regeneration or destruction. When it comes to the care of historic structures, these two can be different sides of the same coin. It all depends on your point of view, and meeting the needs of an increasing number of travellers has frequently left developers and conservationists at loggerheads. A degree of change is inevitable, and Paddington had already seen significant expansion in the first half of the twentieth century, both in Edwardian times and again in the 1930s, but the point comes when the amount of available space for new development runs out and something has to give. That's just what happened as the new Millennium dawned.

The first phase of a bold plan for refurbishment and improvement was instigated in the 1990s. This saw the resurfacing of platforms and concourse floors with limestone, renovation of the vaulted roof using the latest profiled metal sheeting and weight-saving polycarbonate glazing, and the restoration of Digby Wyatt's metal tracery at the gable end. Furthermore, a general declutter, including the replacement of cumbersome destination boards with realigned plasma screens, restored unimpeded views of the roof, while the revamped Lawn was turned into an oasis of calm for a new breed of cappuccino-sipping travellers.

Universally acclaimed, Phase 1 had been the acceptable face of progress, the sugar-coating on the pill, while Phase 2 would prove to be far more contentious. In particular, the developers caused a storm of protest by pushing for the demolition of Span 4 in order to create an enlarged concourse area with a canal-side entrance, plus booking hall and facilities for the proposed Crossrail link between East and West London. It was, they argued, all in the name of architectural purity, but visualisations of the scheme revealed blocks of glass-fronted offices rising above the station. Thankfully, good sense prevailed and in 2009 work commenced on a £26 million restoration of the Edwardian steel roof of Span 4 and removal of the crash deck (installed to protect travellers from falling debris) to allow the natural light to flood in once more. Crossrail's booking hall and facilities are now to be located beneath Eastbourne Terrace itself, with access via a revamped Departures Road. A new taxi area and station entrance is being created on the London Street side of the main station.

*Opposite page:*
A restyled Lawn for the new breed of twenty-first-century rail travellers.

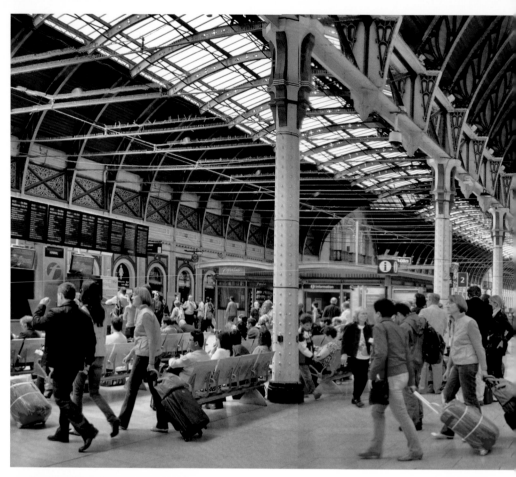

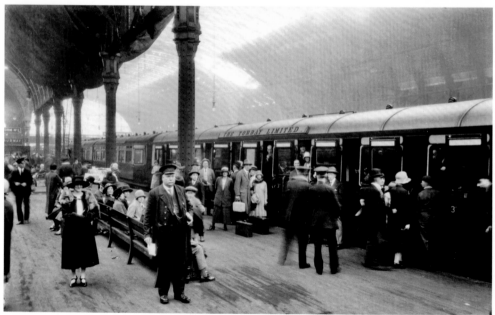

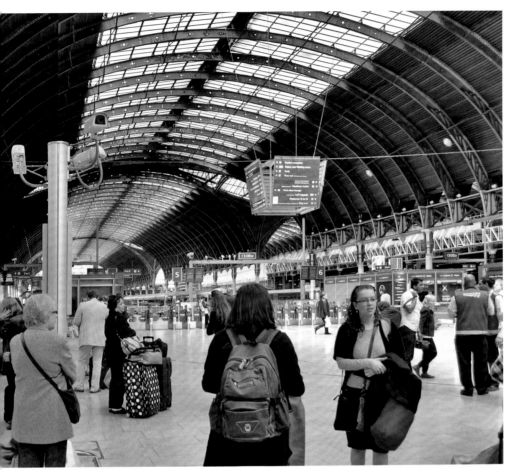

## Gateway to the West

'The termini of a capital city are part of the lives of the nation, they witness the smiles of welcome, the sadness of goodbye, and the many hours of compulsory boredom for the uninitiated,' wrote Sir John Betjeman in 1972. Sometimes noisy, almost always busy, all human life is to be found here: holidaymakers boarding The Torbay Limited on Platform 3 in 1926 (STEAM Museum of the GWR), a brief encounter from the 1950s (US Library of Congress) and, above, the daily comings and goings of a modern city.

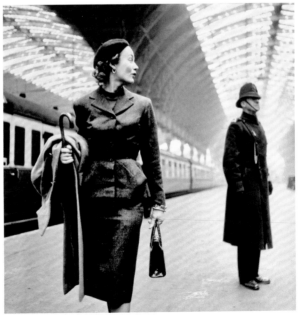

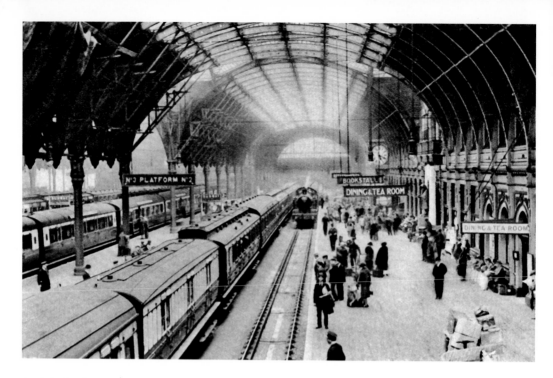

## Back to basics

Paddington has seen many changes over the years, but at its core is Brunel's visionary design, one that has withstood the test of time and copes with new demands and increased traffic levels far higher than even he could have envisioned. Phase 1 of a refurbishment plan instigated in the 1990s saw the resurfacing of the platforms, the renovation of the roof, a revamped Lawn area and a general declutter to restore an unimpeded view of Brunel's masterpiece. The upper view of Platform 1 dates from the 1920s, while the lower one shows the central platforms in 2010.

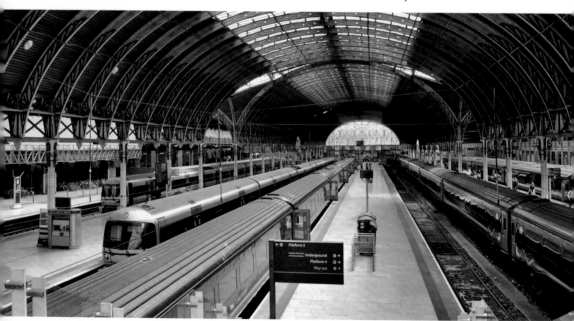

## A brand-new Lawn

Completed in 1999, as Phase 1 of a £24 million makeover, the architect firm of Nicholas Grimshaw & Partners gave the Lawn a new glass roof. With metalwork by Eiffel, this provides views up to the back of Tournament House. The new Lawn is enclosed within a glazed screen to create a climate-controlled quiet zone for waiting travellers. Escalators and stairs lead up to a mezzanine level for further retail outlets or access through to the hotel, while on the ground floor passengers can check in to the Heathrow Express.

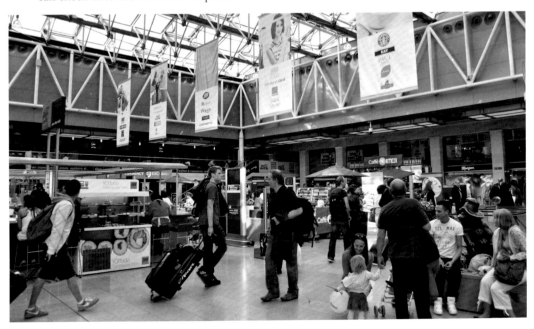

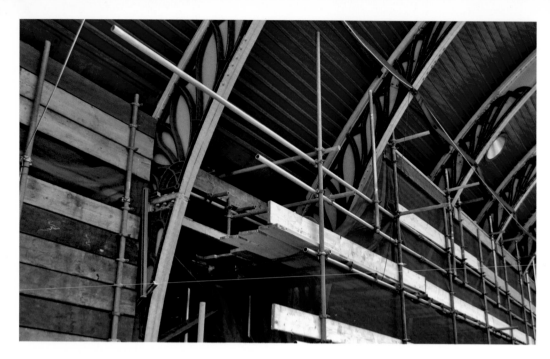

## Saving the fourth span

Phase 2 of the refurbishment was to have seen the demolition of Span 4 to create space for the new Crossrail line. Following widespread protest, the span has now been reprieved and in 2009 work began on its restoration. By 2010, the cladding had been stripped back to reveal the bare bones of the structure, its steel girders. Note the perforations which mimic the 'stars and planets' motif on Brunel's original iron arches. Once completed, it will bring a lightness to the interior of the station that has been absent for some time.

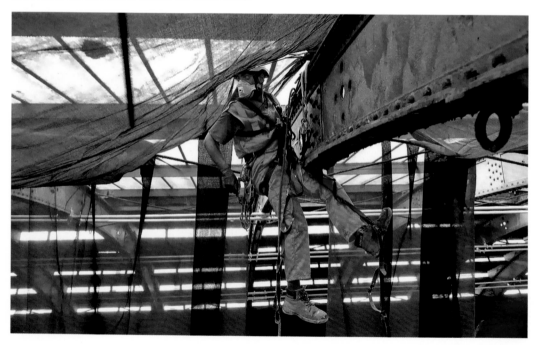

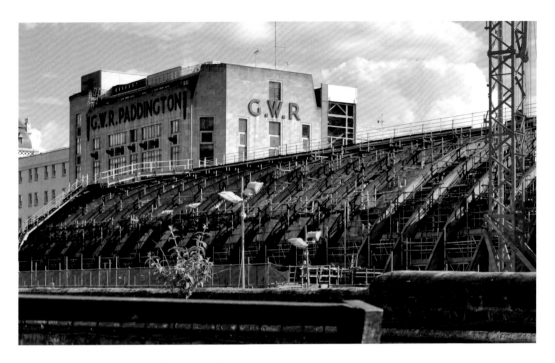

### Fourth span and north side development

By the summer of 2010, the fourth span had been laid bare as part of the restoration process, as shown in this photograph looking towards Tournament House. It's not just the roof that requires attention. The engineers will also work on the structures supporting London Street plus the network of bridges and walkways on this side of the station. Work has already commenced on relocating the taxi rank to the north side, and the old Bishop's Road Station will be 'reconstructed' with a modernistic entrance from the canal side.

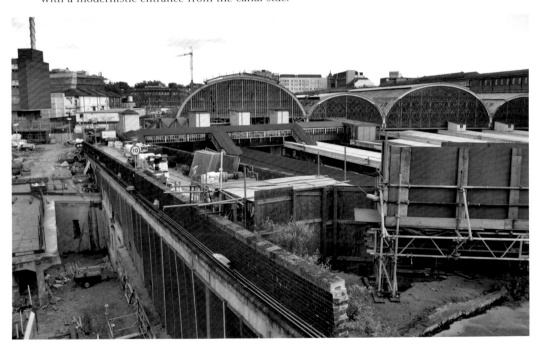

## New Departures and Crossrail

The greatest change coming to Paddington is undoubtedly the new Crossrail station, which will take the form of an underground box located directly underneath the Departures Road and Eastbourne Terrace. The entrance will be in the same place as the existing entrance to Paddington, and there will be new passageways and tunnels connecting with Paddington's assorted Undergound stations. Construction is scheduled to commence in April 2011, conducted in two phases to minimise disruption, with the Crossrail train service expected to begin in 2017.

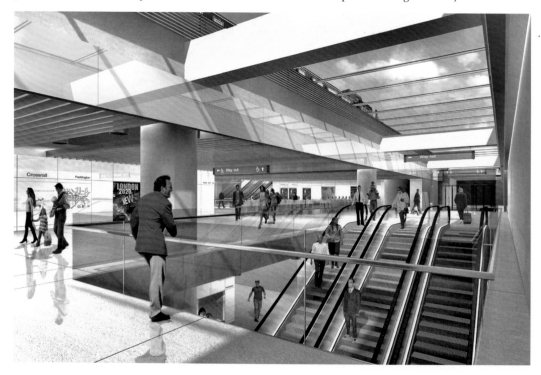

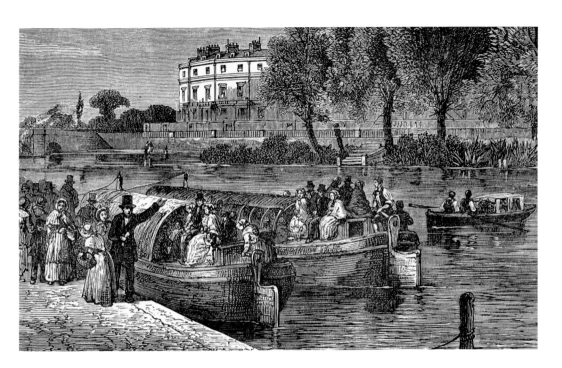

### Paddington Basin

One factor in Brunel's choice of this site for his railway terminus was the proximity of the Paddington arm of the Grand Junction Canal. In practice, the railways killed off the canals, and in turn, the GWR's extensive depots and facilities have given way to a new army of navvies building a forest of mixed commercial and residential developments. If historians a hundred years from now are seeking a microcosm of early twenty-first-century architectural thinking, then this is the place to come. Would Brunel have approved of these steel and glass upstarts? Of course he would.

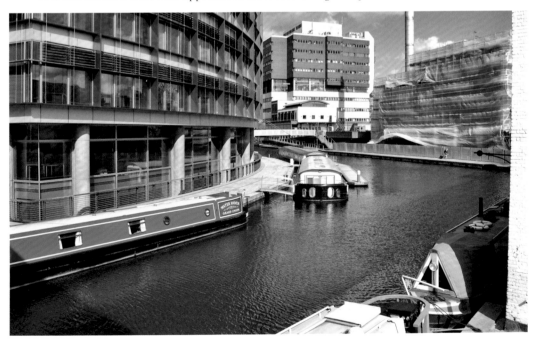

'Spendid run! Thank you!'
Illustration from a GWR poster
of the 1920s.

# Acknowledgements

I would like to acknowledge and thank the many individuals and organisations who have contributed to the production of this book. In particular, Campbell McCutcheon of Amberley Publishing for coming up with the idea of including this treatment of Paddington Station within the 'Through Time' format as a follow-up to *Isambard Kingdom Brunel Through Time*.

Unless otherwise credited, almost all of the new photography is by the author. Additional images have come from a number of sources, and I am grateful to the following photographers: James Lawrence, Keith Long, John Furnevel, Michael Hill, and Jem Gibbs. From various organisation I must thank David Dyer, MD of Dorman Long Technology Ltd, Elaine Arthurs of the STEAM Museum of the Great Western Railway, Robert Excell of the London Transport Museum (Transport for London), Peter James, Miriam Price of King's College London, plus the National Media Museum and the US Library of Congress. From the railway companies, I am grateful to both Rail Track and Crossrail for photographs, and especially the staff of Paddington Station for their friendly help on many occasions.

Final thanks go to my wife Ute Christopher who assisted with proof-reading, to our children Anna and Jay, and last, but by no means least, to Isambard Kingdom Brunel for making life that little bit more interesting. Apologies to anyone left out unknowingly and any such errors brought to my attention will be corrected in subsequent editions. JC